Paul Nash's Photographs

ANDREW CAUSEY

Paul Nash's photographs

Document and Image

THE TATE GALLERY

ISBN 0 900874 59 7 Cloth 0 900874 58 9 Paper

Copyright © 1973 The Tate Gallery
Published by order of the Trustees 1973
Designed and published by the Tate Gallery Publications Department, Millbank, London SWIP 4RG
and printed in Great Britain by Balding & Mansell Ltd, Wisbech, Cambs.

Contents

Cover
Paul Nash photographed by Mrs Clare Neilson

Frontispiece
Paul Nash photographed by Helen Muspratt

Foreword

Paul Nash's activity as a photographer is comparatively little known, but it seems that he regarded photography as an important adjunct to his career as a painter. Certainly many of his photographs show a similar interest in unusual compositions and the same sort of poetic response to the beauty and mystery of the English landscape.

In 1970 the Paul Nash Trust most generously presented all his surviving negatives, numbering 1061, to the Tate Gallery Archive of Twentieth-Century British Art, together with the corresponding number of prints. The selection we are now publishing covers all the different categories, except that we have included only a token representation of the photographs of a purely documentary kind (mostly views of country houses and cottages or of R.A.F. aeroplanes taken during the war) and of those which are obviously casual snapshots.

The selection was made by Dr Andrew Causey of Manchester University, who also has written the introduction and notes to the photographs. Without his scholarly research the book could not have appeared. We are grateful too for the help we have received from Anthony Bertram, Miss Ruth Clark, Miss Margot Eates, Miss Helen Muspratt, Mrs Clare Neilson and Mrs Anstice Shaw.

Norman Reid Director

List of Plates

ANDREW CAUSEY

Paul Nash's Photographs

Paul Nash worked regularly with a camera between 1930, when he was 41, and his death in 1946. In September 1931 he went to the United States as British representative on the panel of judges for the Carnegie International Art Exhibition in Pittsburgh, and for the occasion his wife gave him a camera. It was the only one he ever owned, an American-made No 1A pocket Kodak series 2, a simple machine, with a choice of exposures of one twenty-fifth and one fiftieth seconds as well as 'time' and 'bulb', and aperture openings calibrated 1, 2, 3, 4.

Nash was not mechanically minded, nor curious about the technical side of photography. He regarded his camera as the tool of his imagination, and his work advanced through trial and error, so that the wastage of film, particularly at first, was considerable. His photographs were not primarily mementoes of places and events and he hardly ever photographed people. His work as a photographer complemented his research as a painter.

At the time his photographic career was beginning, Nash reviewed a French anthology, *Photographie*, for *The Listener*, and quoted from Philippe Soupault's introduction: 'Ce qu'il convient surtout de souligner avec la plus de force, c'est qu'une photographie est avant tout un document.' 'Certainly that needed to be stated' Nash added.[1] From the first Nash sometimes used photographs instead of sketches, and from the late thirties, when his asthma began to prohibit prolonged work out of doors, he increasingly made watercolours direct from them. Nevertheless his photographs were not merely documents. There are many in which his sensibility guides the camera to the discovery of shapes and textures which most people would have missed. The records he made on film are valuable in themselves, apart from the role they played in his painting. They are the product of the same ambition as his painting, to discover the patterns and dissonances, the analogies and contrasts which give each aspect of the visual environment its particular animation. His conclusion in 1931 was that 'Photography may not be termed an art, but there are certainly artists in the medium of photography'.[2]

Nash's photography usually developed in style parallel with his painting. The earliest photograph here is probably the derrick on the quayside at Orford in Suffolk taken in September 1930 when he was staying at Snape with his friend Lance Sieveking, who was keen on photography and was perhaps the person who encouraged Nash to take it up seriously. The sharpness with which the shapes are presented gives the photograph its extreme realist quality, comparable to the realism of many of his watercolours of 1930–32. In seeking a firmly structural expression Nash was moving in a direction being followed by many English artists at the beginning of the thirties,

and in particular he was responding to the influence of his friend the critic R.H. Wilenski who was calling for a more architectural mode of painting.

One of the headings that Nash listed for the projected continuation of his uncompleted autobiography, *Outline*,[3] was 'ship architecture', referring to the American trip of 1931. He described the hard outlines of the ship's architecture with precision in his photographs, setting the sharp forms of guard rails, ventilators and deck housing against the steady swell of the sea and the still flatness of the sky. The *Architectural Review* for that September included an illustrated article called 'The Architecture of the Liner' by Lord Clonmore which may have given Nash, a regular reader of the magazine, his initial idea. But his own photographs, evocative rather than descriptive, are an imaginative response to the forms around him; they share something with the work of the American realist artist-photographer Charles Sheeler who had recently done his well-known painting of ship architecture, *Upper Deck* (1929),[4] which Nash might have come to know when he was in America. The individuality of Nash's photographs lies in a near-metaphysical quality attained through the very palpable presence of the finely delineated machine forms against the seeming endlessness of the sea and sky.

This is a quality close to that achieved by the American poet and novelist Conrad Aiken in his novel *Blue Voyage* (1927) which describes a transatlantic traveller surrounded on the one hand with the complex fabric of leisure activities typical of shipboard life—which Nash loved and participated in—and, on the other hand, face to face with the vast solitude of the ocean. Aiken was one of Nash's closest friends when the painter was living at Rye (1930–33), and gives the only published eyewitness account of Nash at work as a photographer. 'You would meet him anywhere, everywhere; perched on a stile miles from anywhere in the middle of the [Romney] marsh, you would find him waiting to get a very special and particular light on the reeds. . . . Once I discovered him astride an old wreck of a steamroller, which had been abandoned by a corner of the muddy little river. And once flat on his belly in the middle of the path to the shipyards, taking, from that earthworn angle—angleworm?—a peculiar foreshortened photograph of some up-ended, half-finished fence posts. In fact, he was into everything.'[5]

Aiken's last reference is to pls.8 and 9 which are among the few photographs that can be dated with certainty to the years 1932–33. A considerable group belongs to the spring of 1934 when the Nashs, who had wintered in the South of France, took a cruise to Spain and North Africa. Here, for the only time, people are common in his photographs, and in the carnival pictures especially one has the

sense of Nash recording direct and momentary involvement in a celebration. But others from the same trip recall the silent ruminative qualities of the Atlantic pictures. One of the finest is *Moorish Quarter, Tetuan, North Africa,* in which light is used to pick out the texture of stone and cobble, and alternation with shadow gives a powerful sense of recession in space, culminating in the light on the distant flight of steps. The strong Mediterranean sun gave him contrasts which he used well.

Regrettably there are only a few architectural studies of this kind. Similar contrasts of sun and shadow in pl.22, create an ambiguous and mysterious kind of space, and a related device used to pit definition against uncertainty is the light falling through the intermittent bands of railings in pl.23. Nash also extended this technique into landscape. The same narrow but well-lit distance that appears in pl.24 recurs in pl.25. Here the broad tree trunks held tightly within the upright format, together with the fence and barbed wire, constrict the spectator with a feeling of the looming presence of the foreground which is contrasted with the narrow band of well-lit distance on the left.

Nash's photographs of Spain and North Africa began to gain him recognition. He wrote to his friend Ruth Clark in about July 1934: 'My reputation as a photographer is growing alarmingly. I am pretty certain it will eclipse mine as a painter unless I take a firm line. If the truth were told photographing has enormously widened my picture vision so that when I begin on a period of painting I shall feel the benefit, as they say.'[6] His sense of recognition may have related to Raymond Mortimer's article on his photography, 'Nature imitates Art', which the *Architectural Review* was to publish in January 1935, and which may already have been proposed.

Now, in the summer of 1934, Nash's photography took a new direction. The notion that a photograph is primarily a document gives ground to the idea that a photograph may be an original, and even abstract, work of art. His still life photographs of this period, composed with pieces of wood, stones, fossils and a tennis ball, are not easy to evaluate because only one, pl.27, was reproduced in his lifetime, and we guess how he would have trimmed them only from the few examples of prints that he cut and of prints or negatives which he marked. In the case of the compositions on top of the closed car hood, he would almost certainly have cut away all the background and have made the composition as abstract as possible by focusing on the still life alone.

This fresh turn in his photography was probably in part a response to the growing interest in pure abstraction manifested by other members of the English avant-garde during 1934. Nash seems to have turned his attention

back to the work of photographers he already admired who worked in a more abstract way: Moholy-Nagy and Man Ray. He had previously described Moholy-Nagy in his article in *The Listener* in 1931 as 'one of the most brilliant of the modern men', and he had mentioned Man Ray in the article as well. Moholy-Nagy was to settle in London in 1935, and was already friendly with several leading British artists—though he had probably not met Nash who was in London very little in 1933–34; he had had his photographs published in the *Architectural Review* and *The Listener,* and had presented his case for photography being a new art form in *The Listener.*[7] In some still life photography, Nash, using unusual subject matter and camera positions, achieved effects of shadow and texture similar to Moholy-Nagy's. A photograph like pl.32, which shows a group of objects on a doormat framed by a wooden lintel on two sides and with the stone outside wall of the house on the left, combines skilful lighting (the effect partly contributed by his own shadow), a consequent richness of texture, a sense of pattern in the design and of event in the way the light falling on the small objects raises them out of their dark surroundings. Equally, however, some of the other compositions are lifeless, without meaning as abstract groups or mystery as encounters between objects.

By 1935 Nash's painting was turning decisively away from near-abstraction and towards interpretations of landscape again, and the research into still life photography was not pursued. From the autumn of 1934 to early 1936 the Nashs lived chiefly at Swanage in Dorset, and early in 1935 Nash was commissioned to prepare the *Dorset Shell Guide* which he completed in December.[8] Gathering information for the gazetteer required regular travel through the country and a massive amount of photography. The guide contains eleven photographs by Nash as well as montaged front and back covers and endpapers and reproductions of four specially made watercolours. Some of the photographs are direct, descriptive records, while others, like *Chesil Bank* and *Coast at Kimmeridge* are original and expressive designs.

Nash had written in his 1931 article in *The Listener*: 'For some years I have made a collection of photographs showing character of design or pattern.' The article was illustrated by a close-up photograph of sandwaves by John Havinden, one of the contemporary English photographers who interested him most. In the best of the Dorset photographs Nash pinpoints aspects of design and pattern and stresses analogies between shapes in natural or man-made things: stone walls, earth ramparts, ploughed furrows and haystacks, the sea swelling and breaking, and the patterning on the bark of trees. He manages to invest the ordinary with a distinctive presence and to create

mood corresponding to his own sense of the nature and character of the place or thing.

Behind his interest in pattern lay a train of thought which linked with Nash's painting in the mid-thirties and his decision to remain a landscape painter without wholly abandoning abstraction. It was the idea presented by Wilenski who attacked in his books *The Modern Movement in Art* and *The Meaning of Modern Sculpture* [9] 'the Romantic notion of a wild, free, ragged nature'. In the second book Wilenski reproduced photographic enlargements of plant life from Professor Karl Blossfeldt's *Art Forms in Nature*, demonstrating the geometry of natural growth. Nash reviewed the second volume of Blossfeldt's photographs in *The Listener*, noting that 'here we have an intensely interesting example of the peculiar power of the camera to discover formal beauty which ordinarily is hidden from the human eye'. And further on he writes: 'The manifestations of modern photography not only support the statements of many so-called "perverse" sculptors and painters, but run parallel to and, to a great degree, inform the course of modern art.' [10] Nash pursued this interest further by acquiring a copy of the pioneering classic on the subject of the underlying symmetry of natural forms, d'Arcy Wentworth Thompson's *On Growth and Form*. [11] He may have been introduced to it by Herbert Read, on whose thought the book had been a

formative influence. Read later wrote: 'This book, by showing that certain fundamental physical laws determine even the apparently irregular forms assumed by organic growth, enormously extended the analogy between art and nature.' [12]

Nash often seems to have been most at ease photographing locations like Maiden Castle which is so unencumbered with incident that the rhythm of the landscape stands out clearly. There is an element in these photographs which can be called abstract, in the sense that nothing visible impedes enjoyment of the forms of the landscapes, but the grassy ramparts also have an undeniable emotive presence which is in no sense purely formal. In presenting the naked body of the landscape, Nash goes some way to eliminating the sense of it being the object of his photography, of it 'being taken', and tries to let it express its own animate character. It is what Hardy had done for Egdon Heath in the passage from *The Return of the Native* which Nash quoted in his *Dorset Shell Guide*: 'The place became full of a watchful intentness now; for when other things sank brooding to sleep the heath appeared slowly to awake and listen. Every night its Titanic form seemed to await something; but it had waited thus, unmoved during so many centuries, through the crisis of so many things, that it could only be imagined to await one last crisis—the final overthrow.'

Living in London from 1936 to 1939, Nash was no less concerned with landscape than when he had been living in the country. But he became less interested in the documentary aspect of photography, and more intrigued with making his landscapes reveal themselves, and express that 'formal beauty which ordinarily is hidden from the human eye'. The idea of illuminating the hidden character of landscape was the theme of an article he wrote in 1938 for *Country Life*, constructed round some of his landscape photographs and called 'Unseen Landscapes'.[13] He began: 'The landscapes I have in mind belong to the world that lies visibly about us. They are unseen merely because they are not perceived.' Nash took as his first example the prehistoric Uffington White Horse in Berkshire which he had discovered not long before. 'Once the rather futile game of "picking out" the White Horse is abandoned, the documentary importance of the site fades, and the landscape asserts itself with all the force of its triumphant fusion of natural and artificial design. You then perceive a landscape of terrific animation whose bleak character and stark expression accord perfectly with its lonely situation on the summit of the bare downs.' In pl.70 the outline of the horse is visible, carved out of the dry tussocky grass; the photograph has a distinct narrative and historical character, with the distant road on the left and the far plain used not only formally, but also as a spatial paradigm for

distance in time. But in pl.71 the overt narrative quality is abandoned in the close-up view, and the animation of the landscape is described only through detail, the build-up of pressure on the left of the track in the foreground, its release into the curve in the centre, the disappearance of the track, and its renewal in the distance parallel to the line of the grass on the horizon.

Another unseen place was Creech Folly, pl.77, perched on an escarpment of the Purbeck Hills. 'It is a lost place, eternally put out of countenance by an unexplicable intrusion upon its wild privacy.' In the photograph, Nash keeps the folly well back in the picture because the place and its wild privacy are his primary subject matter, and though of course the intruder—'a wan architectural exercise vaguely reminiscent of the Marble Arch'—defines this wildness by the contrast with itself, it must not be allowed to dominate.

Exact spacing was indispensable in establishing the right mood for the sense of discovery Nash wanted to build up. Sometimes he introduced a very close foreground. Bracken or long windswept grass just in front of the camera make a spectator feel like a spy on Creech Folly or the ruined stone buildings on the downs above Swanage, pl.62. In pl.76, each section of space, the hedge, the field, the woods, is carefully defined; but the mood of the photograph emerges only from the contrast between

this clarity of construction and the way the ultimate focus of our attention, the folly, is largely obscured by the trees.

Nash generally felt the need to create an ambience for his subjects in this way. Occasionally he presented them more directly. The three concrete steps in a field, pl.58, possess a presence and an inconsequence which Nash felt needed no disguise, no elaboration of their environment; so they stand squarely in the middle of the picture, turned just far enough for their full form to be apparent.

In 1938 Nash was approached by the publisher Frederick Muller who was interested in issuing a volume of his photographs.[14] The project came to nothing, perhaps because of the coming of the war, or possibly because Nash lacked enthusiasm.[15] He frequently used his photographs directly or in part as subject matter for his paintings, and may not have wanted them shown on their own.[16] Altogether eighteen of his photographs were published in his lifetime, and a small number were shown at the *International Surrealist Exhibition* and retrospective exhibitions between 1939 and 1945.[17]

Fewer photographs can be dated after 1938 than before, despite the fact that ill health made him more reliant on them. Though film was hard to get in wartime, Nash had an allowance of it as an Official War Artist. His late subjects include trees, in particular a series of dead trees done in 1938–39, the aircraft wreckage photographs taken at Cowley dump near Oxford in 1940, the garden at Beckley Park in Oxfordshire, and a few other identifiable landscapes which he took on the occasional trips he made into the country while living in Oxford during the war.

The wreckage pictures are important as constituents of the design of one of his most successful paintings, 'Totes Meer', but they are not in themselves remarkable. His empty landscapes and gardens are more inherently expressive as photographs. In the two photographs of Gregynog, pls.80 and 81, taken in April 1939, the road stands out through its paleness against the surrounding greys, and its emptiness becomes a positive characteristic. The photograph of the road running through the gentle parkland setting has a strange melancholy. A road was a favourite device of Nash in both his photography and his painting for describing distance. During his career as a photographer Nash evolved many ways of forming space. In the Avebury picture, pl. 97, taken in 1942, the distance is tied to the foreground not by a direct link like a road, but by the analogy of shape between the monolith and the clumps of trees on the horizon. To associate foreground with distance, whether literally by a road or track, or by analogy of shapes, or, as in the early Atlantic voyage series, by the direct contrast of solid, close-to-hand elements with the less substantial and more distant sea and sky, was Nash's way of attempting a metaphysical statement.

NOTES

[1] Paul Nash, 'Art and Photography', *The Listener*, Vol. VI, 1931, pp.868–9.

[2] Ibid.

[3] Paul Nash, *Outline, an Autobiography and Other Writings*, 1949, p.223.

[4] Coll. Museum of Modern Art, New York.

[5] From *A Pair of Vikings* in *The Collected Short Stories of Conrad Aiken*, 1960, p.91. The passage could be challenged as a record of fact since it is quoted from fiction. But the references to Nash in Aiken's short stories are completely credible, as are the references in Aiken's autobiography, *Ushant*, 1952, which has a semi-fictional presentation.

[6] The author thanks Miss Ruth Clark for making this quotation available to him.

[7] Professor L. Moholy-Nagy, 'How Photography Revolutionises Vision', *The Listener*, Vol. X, 1933, pp.688–90.

[8] Paul Nash, *Dorset Shell Guide*, 1936.

[9] R.H. Wilenski, *The Modern Movement in Art*, 1927, and *The Meaning of Modern Sculpture*, 1932. The quotation is from the latter, p.158.

[10] 'Photography and Modern Art', *The Listener*, Vol. VIII, 1932, pp.130–31. Professor Karl Blossfeldt, *Art Forms in Nature*, Vol. I, 1929, Vol. II, 1932.

[11] Sir d'Arcy Wentworth Thompson, *On Growth and Form*, 1917.

[12] Sir Herbert Read, *The Contrary Experience, Autobiographies*, 1963, p.345.

[13] *Country Life*, Vol. LXXXIII, 1938, pp.526–7.

[14] Information from Anthony Bertram.

[15] But a volume of 64 photographs, *Fertile Image*, was edited by Margaret Nash, the artist's widow, and published in 1951 at the time of the Arts Council exhibition *Paul Nash's Camera*.

[16] But Nash was later interested in exhibiting his watercolours and the related photographs together; he proposed this for the *War Artists Exhibition* at the National Gallery in 1940. Lord Clark wrote to Nash (22 August 1940) from the Ministry of Information, 'Dickey tells me you brought to show him on Friday some watercolours of aeroplanes which you would like to have exhibited with the photographs taken by yourself on which they are based.

'I am sure I will like both the drawings and the photographs, and I am much interested in the idea of showing the two together, but I am quite certain that from the public point of view it would be a great mistake to do so. Some day an art critic of authority must break down the public distinction between art and photograph, but God forbid that the Ministry of Information should be the first to try and do this, especially as the people who come to see the War Artists Exhibition are usually very simple and have come primarily for non-aesthetic motives. Can't you imagine the indignant letters we would get, and the floods of requests from photographers of the baser sort that their work should be shown too?'.

(Transcripts of Crown copyright records appear by permission of the Controller of H.M. Stationery Office.)

[17] Photographs appeared in Raymond Mortimer, 'Nature Imitates Art', *Architectural Review*, Vol. LXXVII, 1935, pp.27–9; Paul Nash, 'Swanage or Seaside Surrealism', *Architectural Review*, Vol. LXXIX, 1936, pp.151–4; Paul Nash, 'The Life of the Inanimate Object', *Country Life*, Vol. LXXXI, 1937, pp.496–7; Paul Nash, 'Unseen Landscapes', *Country Life*, Vol. LXXXIII, 1938, pp.526–7; Paul Nash, 'The Giant's Stride', an article about Clifton Suspension Bridge, *Architectural Review*, Vol. LXXXVI, 1939, pp.117–20; photographs were exhibited at the *International Surrealist Exhibition*, New Burlington Galleries, 1936 (246–8); Gordon Fraser Gallery, Cambridge, 1939 (20–23); The Council for the Encouragement of Music and the Arts, circulating exhibition, April 1943 (47–9); Cheltenham Art Gallery, 1945 (57–8); *Paul Nash's Camera*, Arts Council touring exhibition, London, November 1951, and Bournemouth, Swanage, Oxford, Manchester, Sheffield, December 1951–April 1952 (1–44).

The Plates

Captions marked * Further reference is made in the notes which follow the plates.

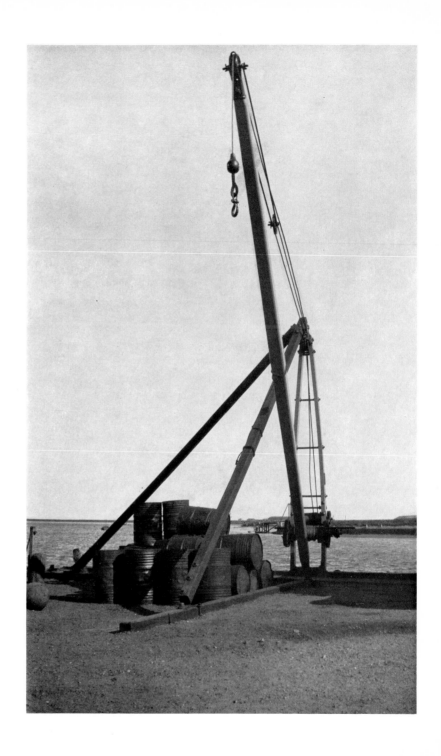

1 Derrick at Orford, Suffolk 1930*

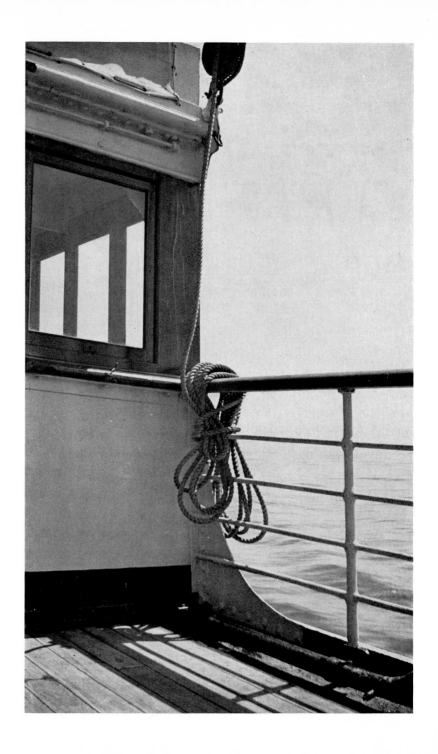

2 Atlantic Voyage 1931*

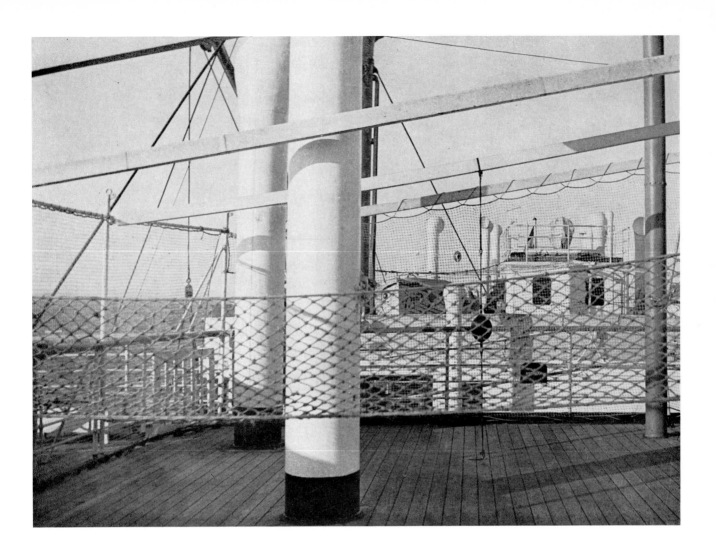

3 Atlantic Voyage 1931*

4 Atlantic Voyage 1931*

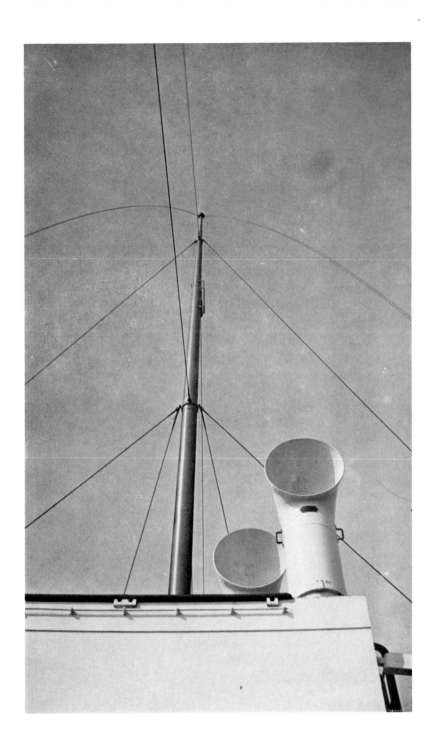

5 Atlantic Voyage 1931*

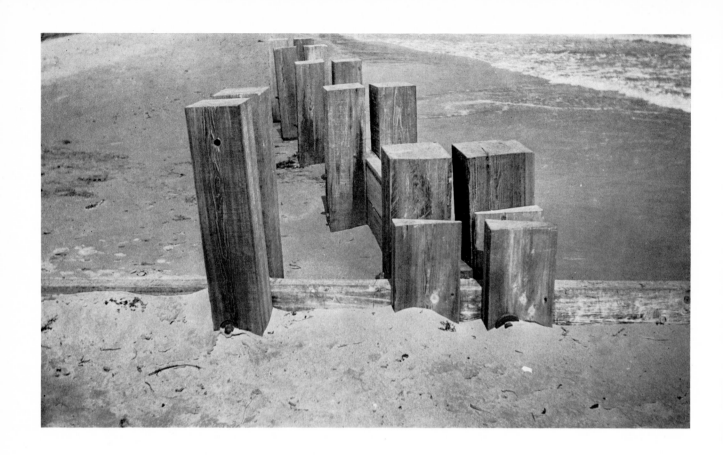

6 Breakwater

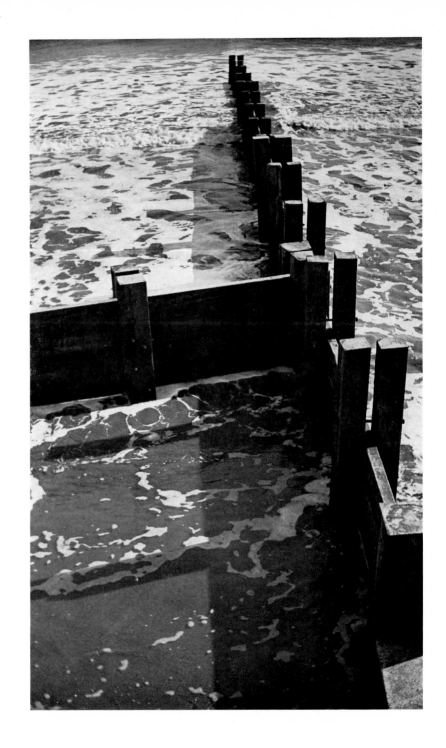

7 Breakwater

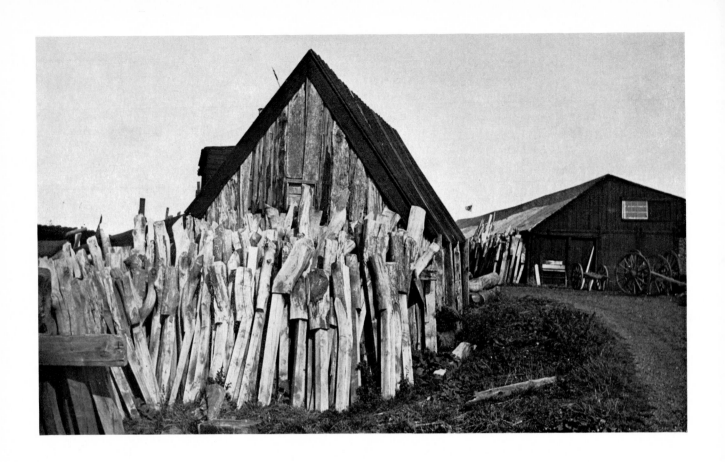

8 Woodstack and Barn, Rye 1932

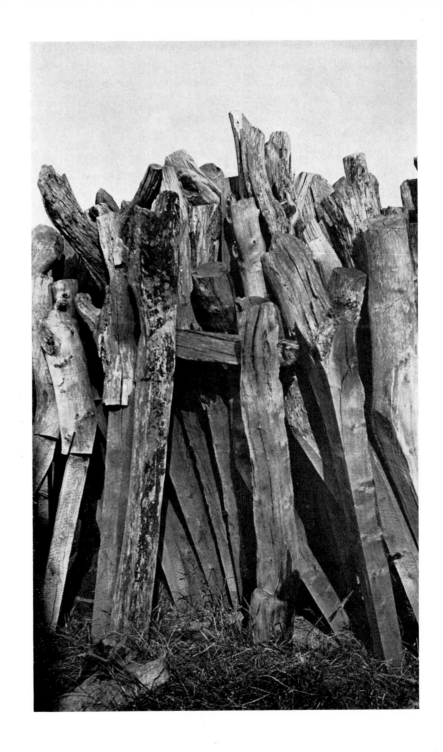

9 Woodstack (detail), Rye 1932*

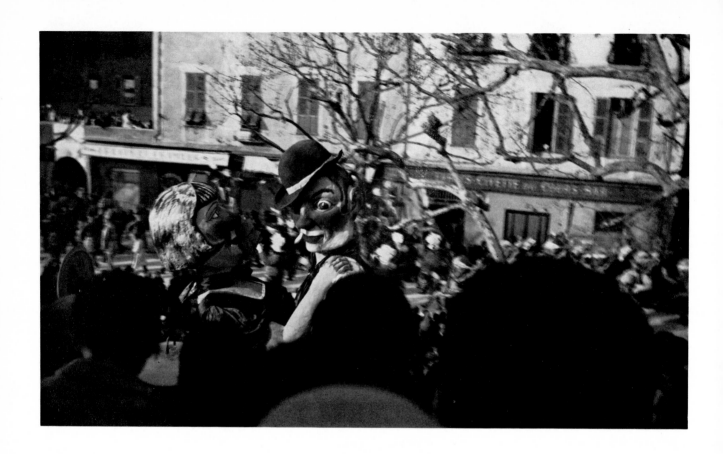

10 Carnival, Nice 1934*

11 Carnival, Spain 1934

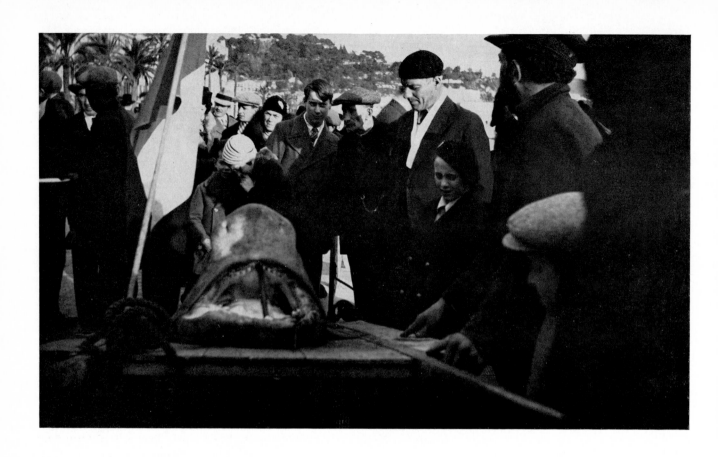

12 People Looking at a Dead Shark, Nice 1933–34*

13 Diving Suits Drying c.1933–4

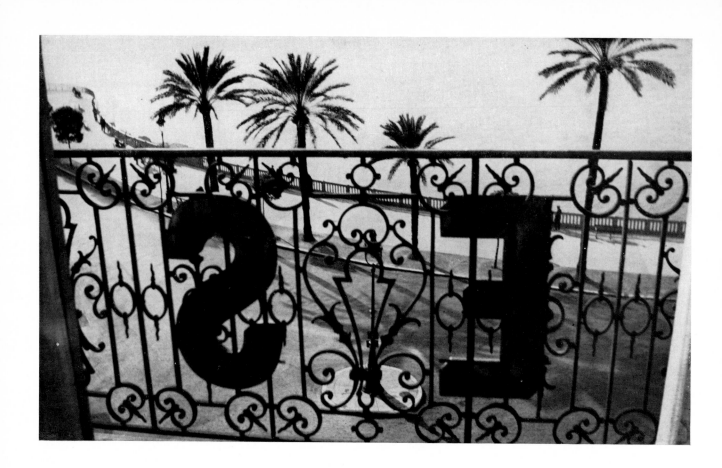

14 View from the Hôtel des Princes, Nice 1933–4*

15 Washing Drying on a Beach c.1933–4

16 A Boat on the Shore at Orford

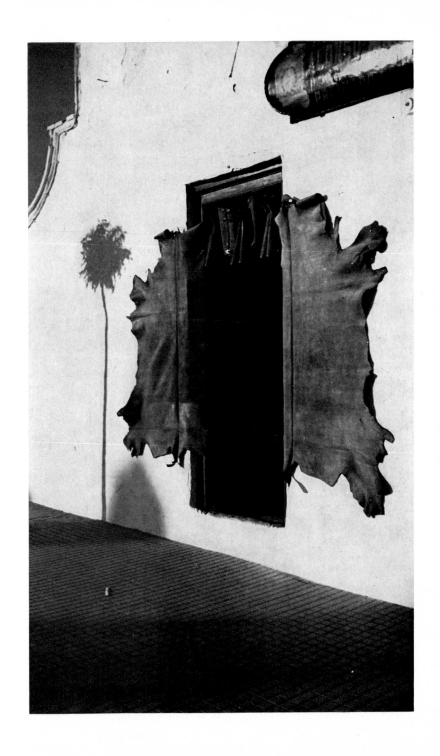

17 Doorway, Spain 1934*

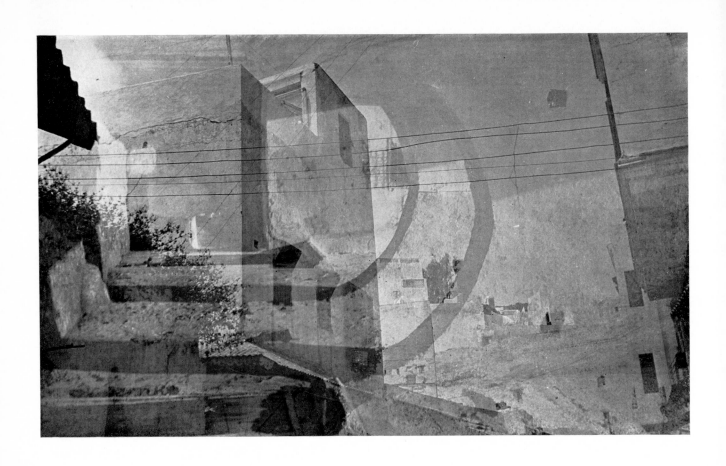

18 Double-exposed Photograph, Morocco 1934

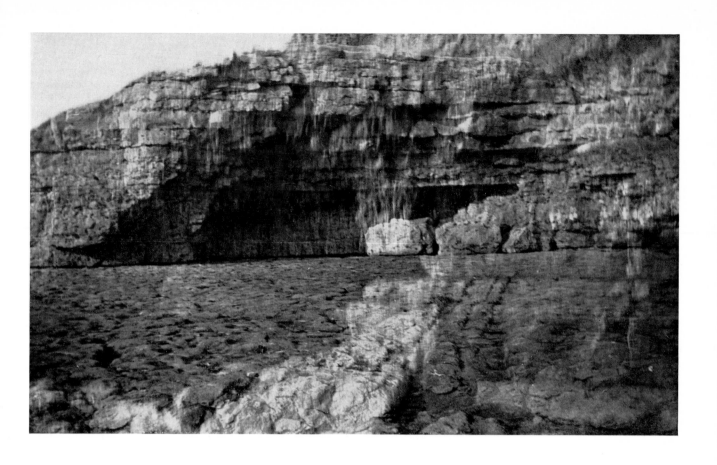

19 A Double-exposed Photograph of Caves at Durlston Head, Dorset

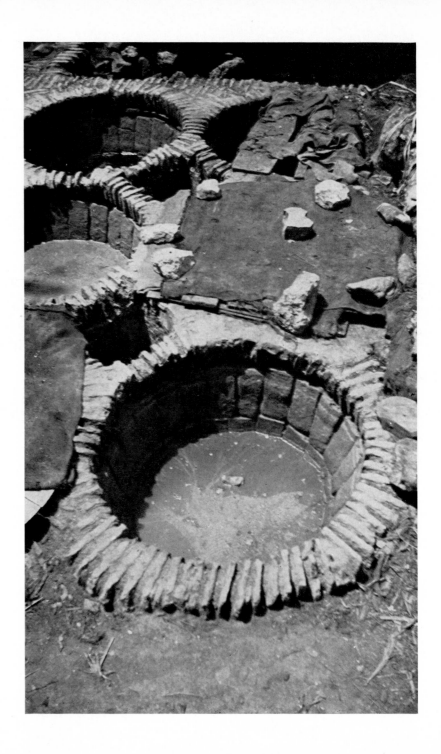

20 Dye Pits, Tetuan, North Africa 1934*

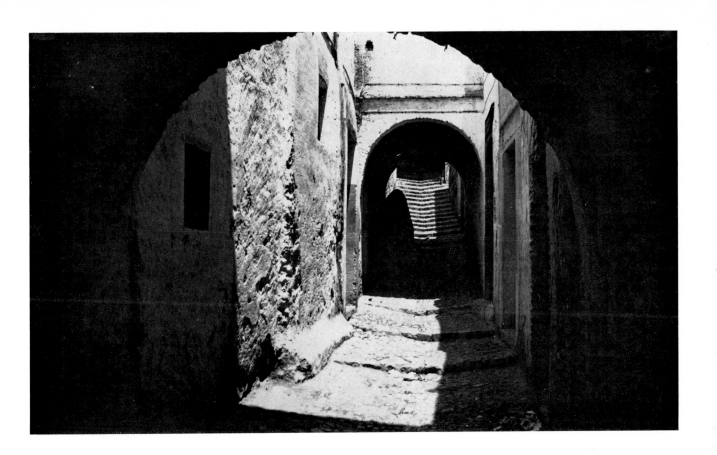

21 Moorish Quarter, Tetuan, North Africa 1934*

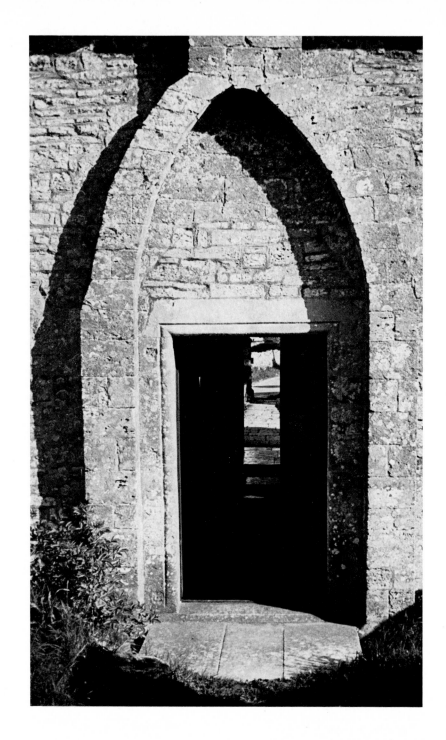

22 Stone Doorway, Spain or North Africa 1934

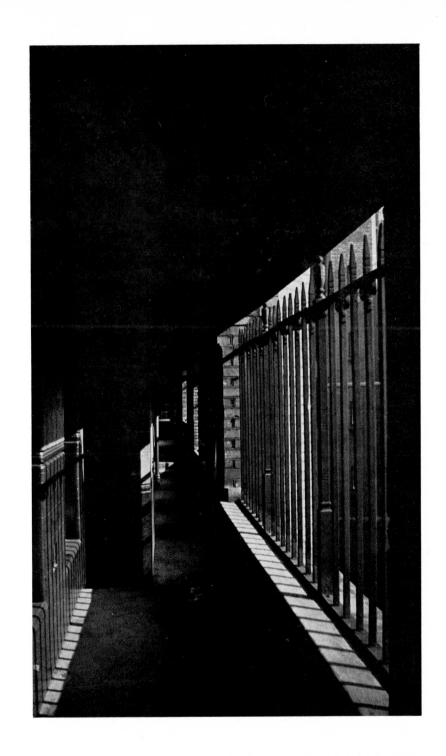

23 Queen Alexandra Mansions, Judd Street,
London c.1932–6*

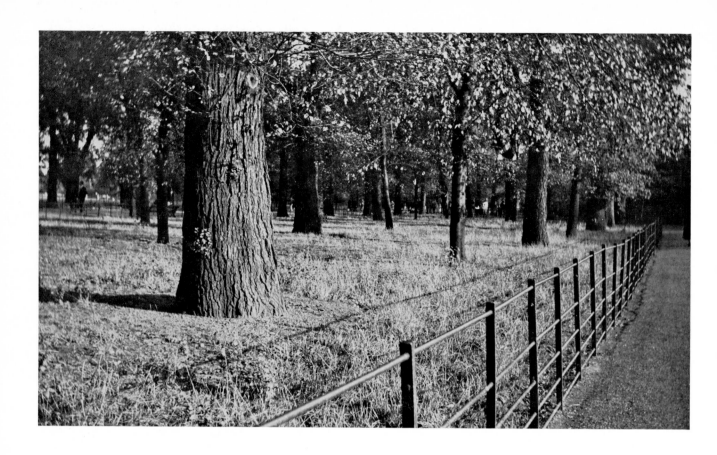

24 Copse by a Road

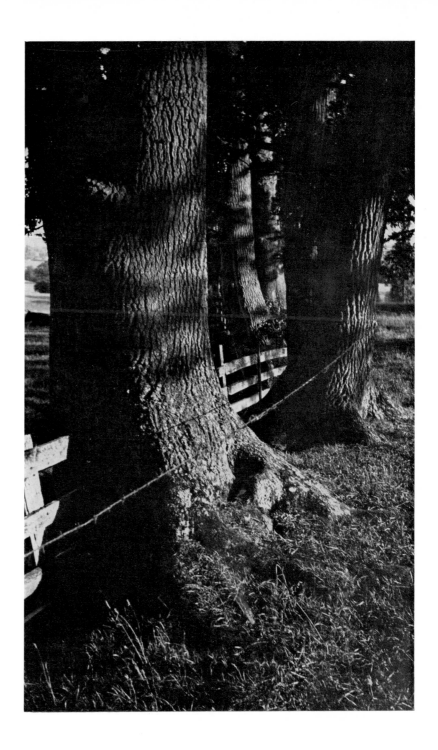

25 Trees and a Wooden Fence

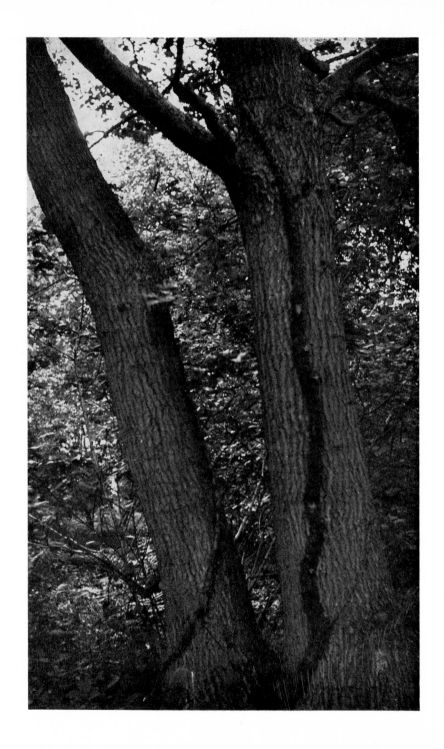

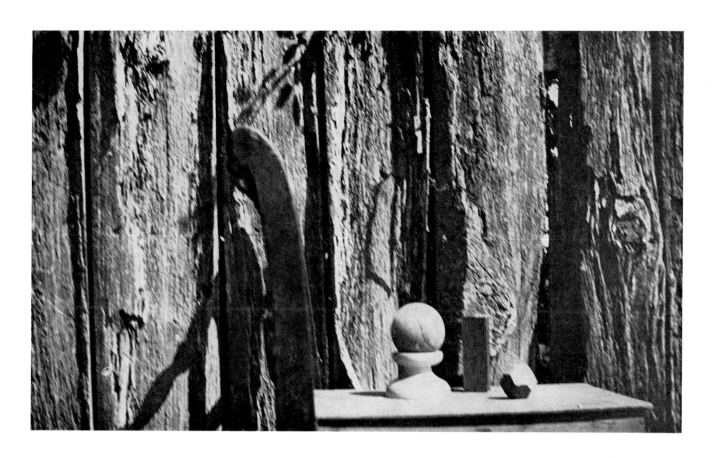

27 Poised Objects c.1934–5*

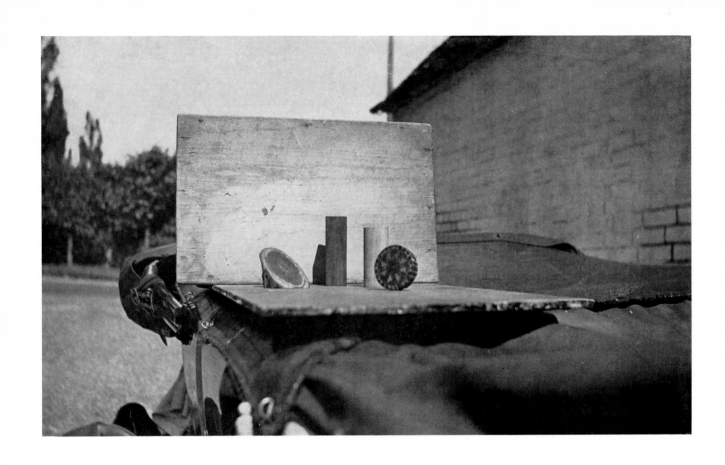

28 Still Life on a Car Roof 1934

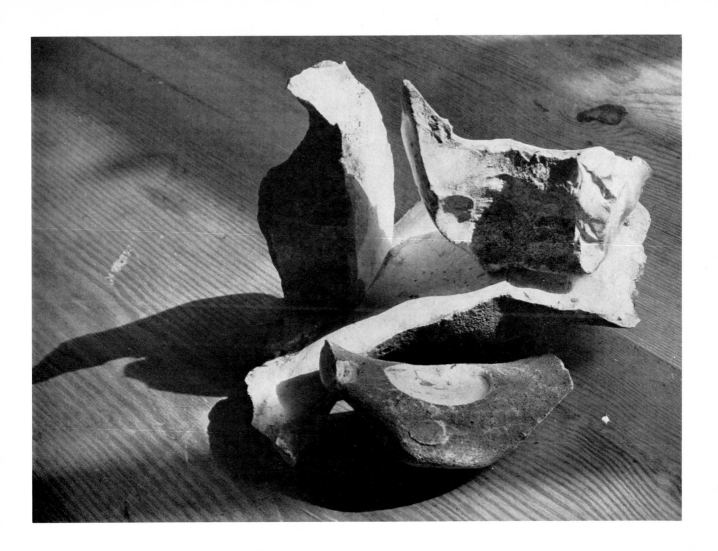

29 Still Life—Flints c.1935–6

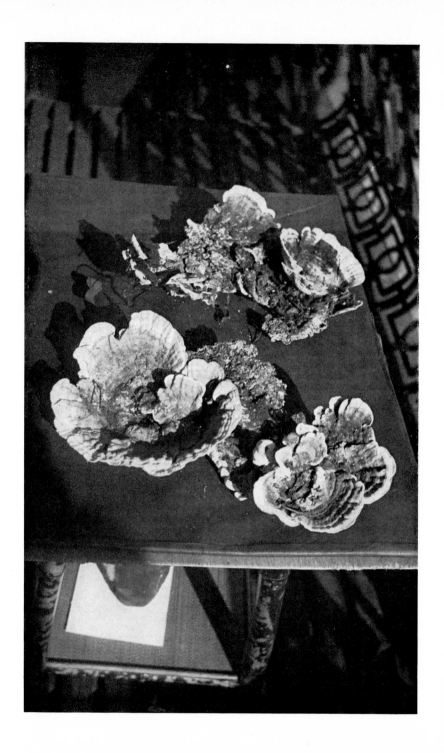

30 Still Life—Fungus 1934*

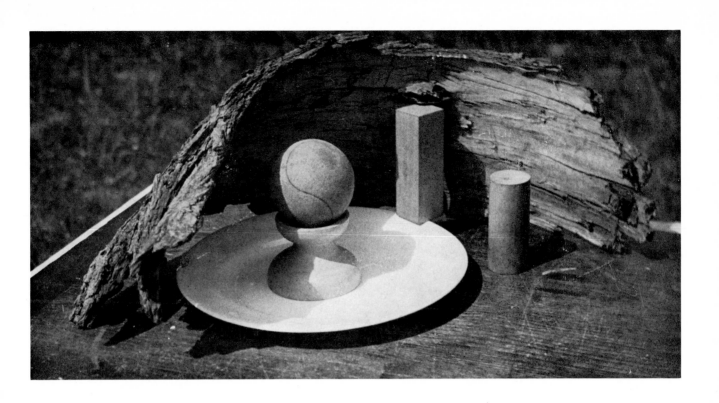

31 Still Life 1934–6*

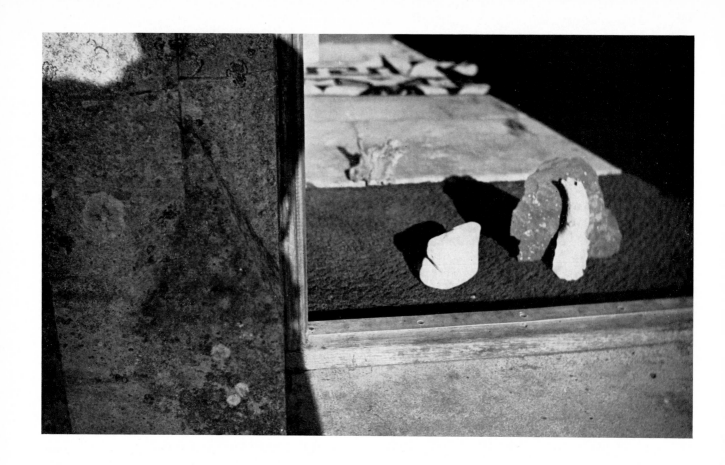

32 Still Life on a Door Mat 1934

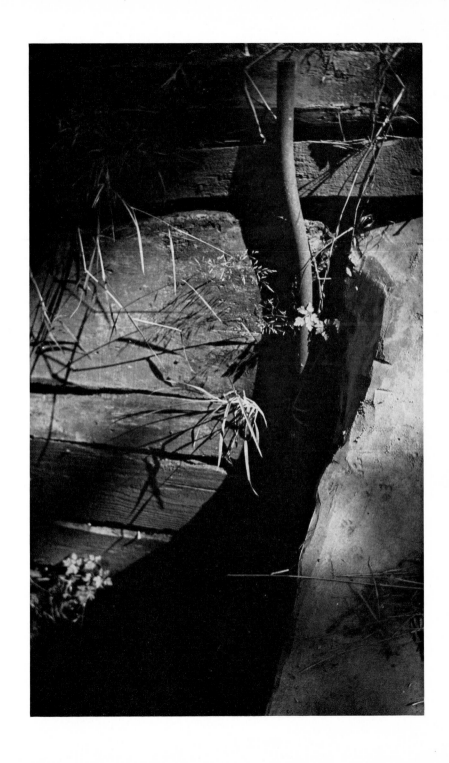

33 The Ditch c.1934–6*

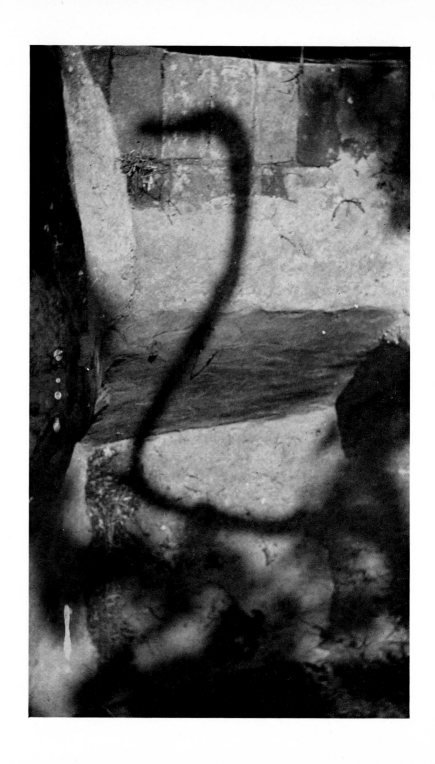

34 Step Edge 1934

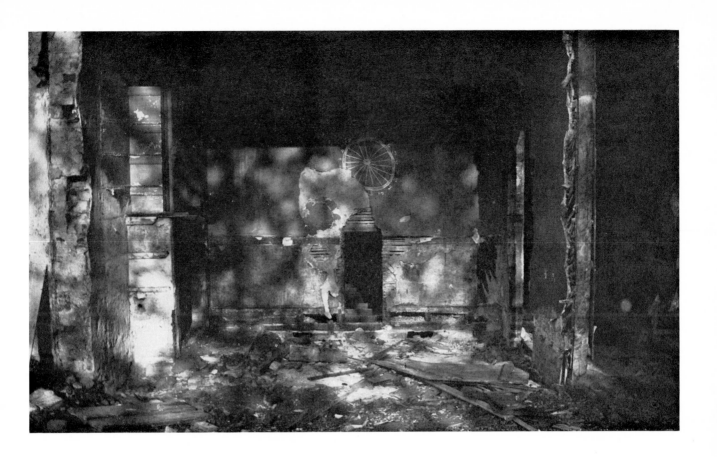

35 'Demolition Landscape'*

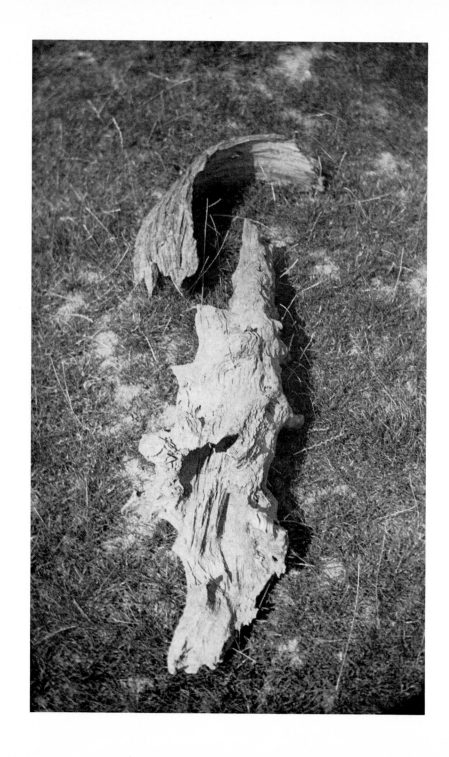

36 'Marsh Personage' 1934*

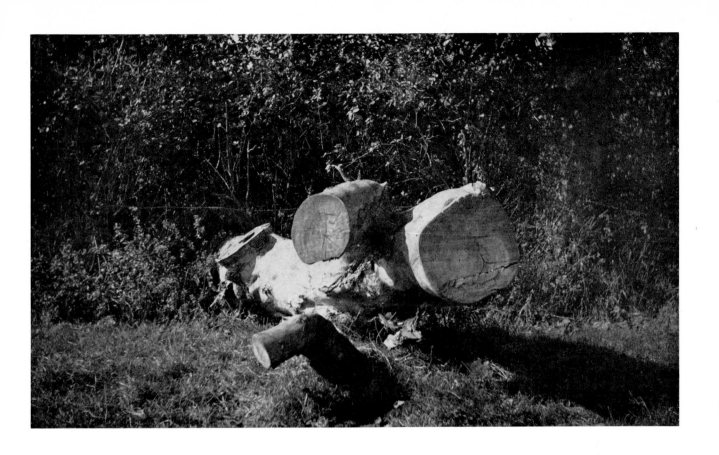

37 'Objet Trouvé' c.1934–7*

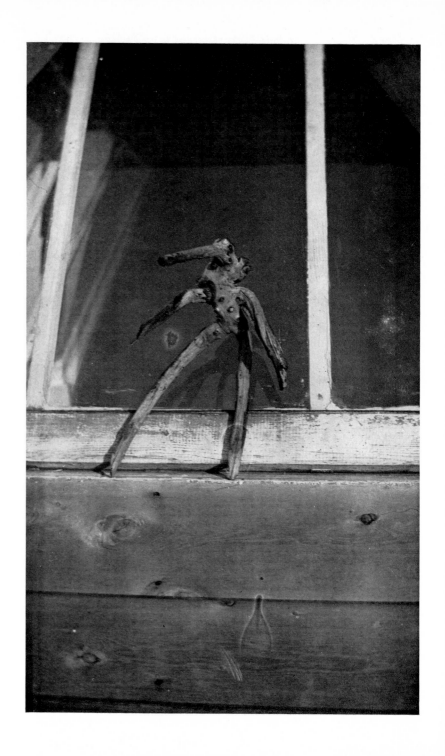

38 'Lon-gom-pa'

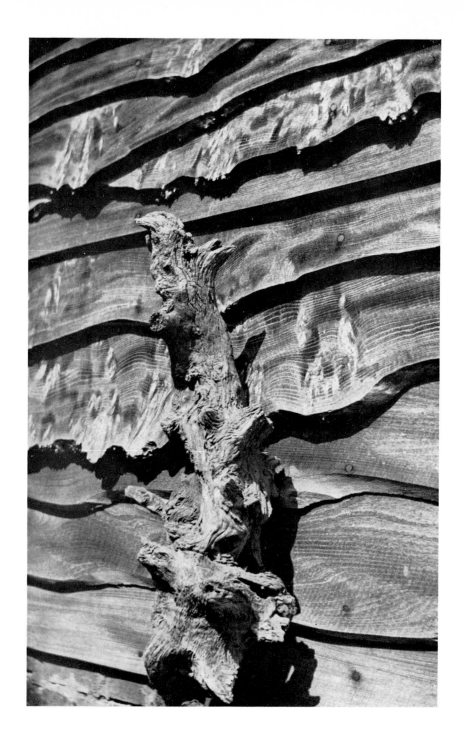

39 'Dracula'*

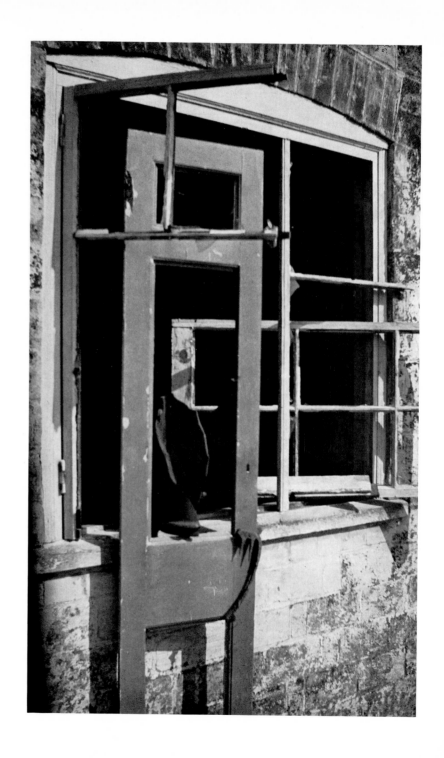

40 Snape c.1934*

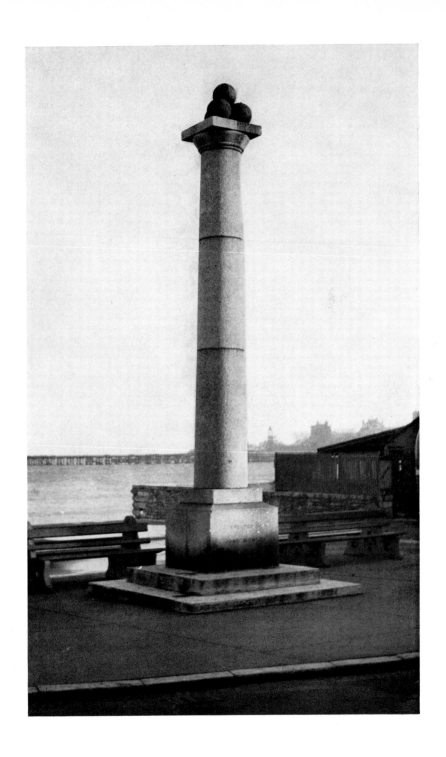

41 Alfred the Great Monument,
Swanage, Dorset c.1935*

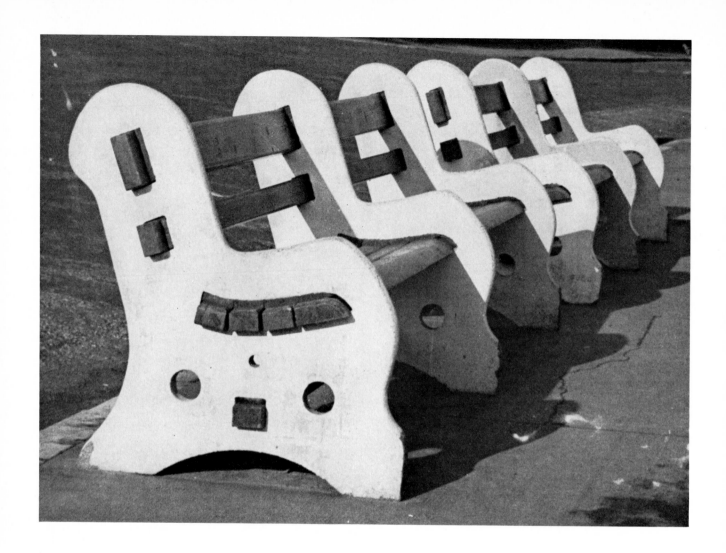

42 Seats at Swanage c.1935*

43 Lamp-post, Swanage c.1935

44 The Parade, Swanage c.1935

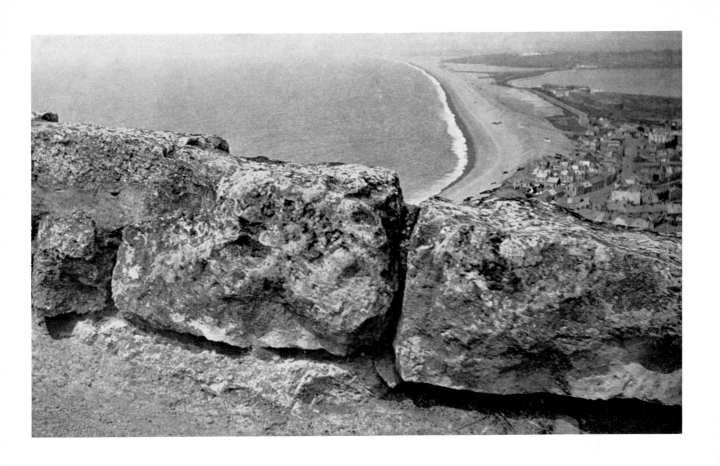

45 Chesil Bank from the Isle of Portland c.1935*

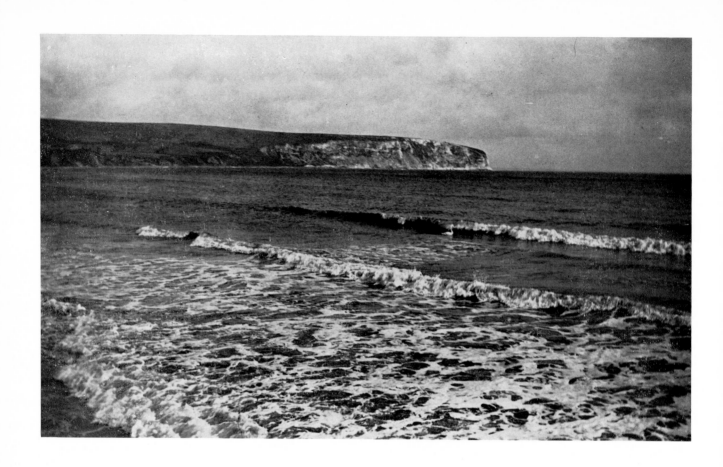

46 Swanage Bay, Dorset 1935*

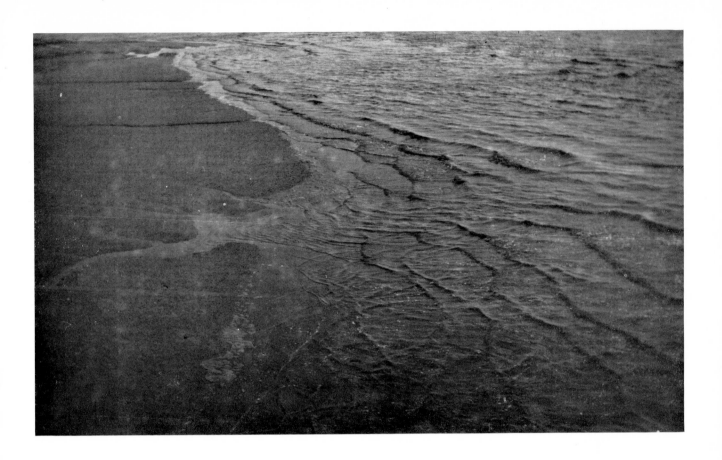

47 Seashore, Dorset c.1935*

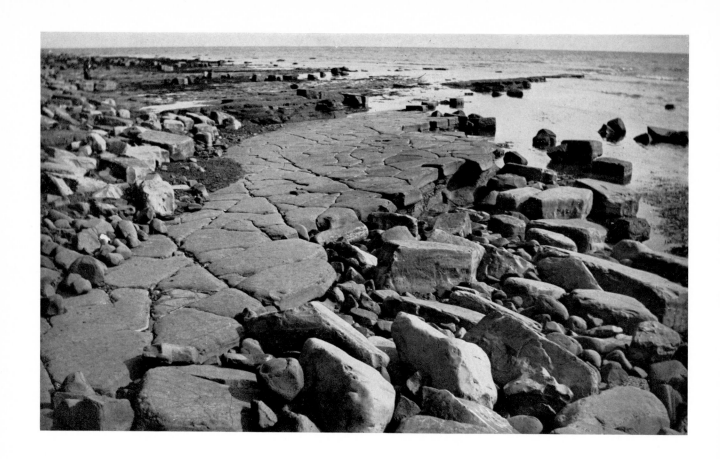

48 The Flats, Dorset Coast c.1935

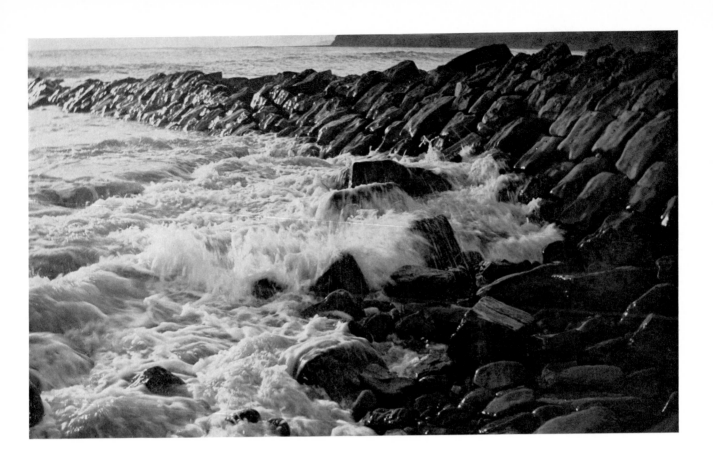

49 Coast at Kimmeridge, Dorset c.1935*

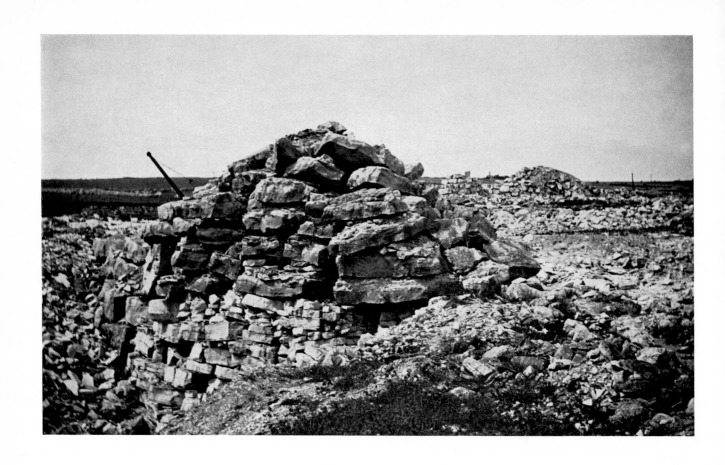

50 Stone Rubble Wall c.1935

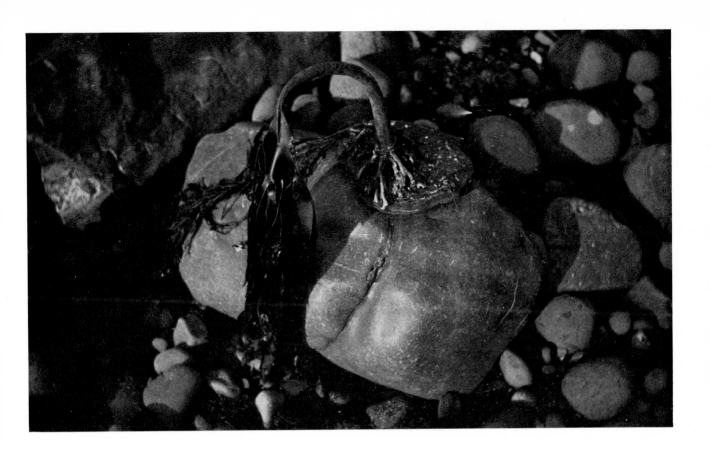

51 Stones and Seaweed c.1935*

52 Pebbles

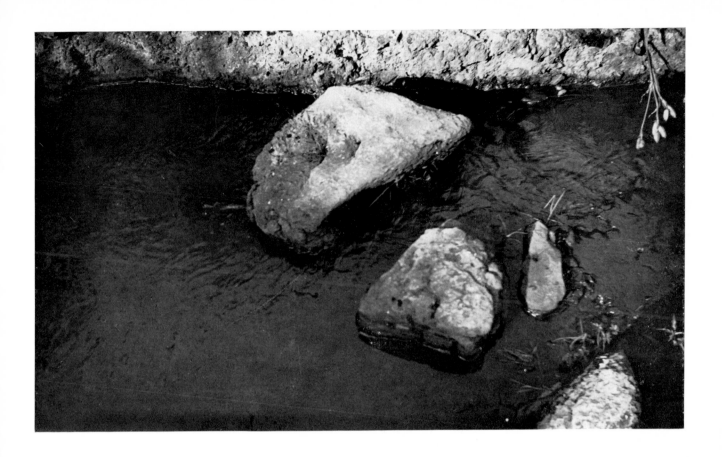

53 Rocks in a Stream

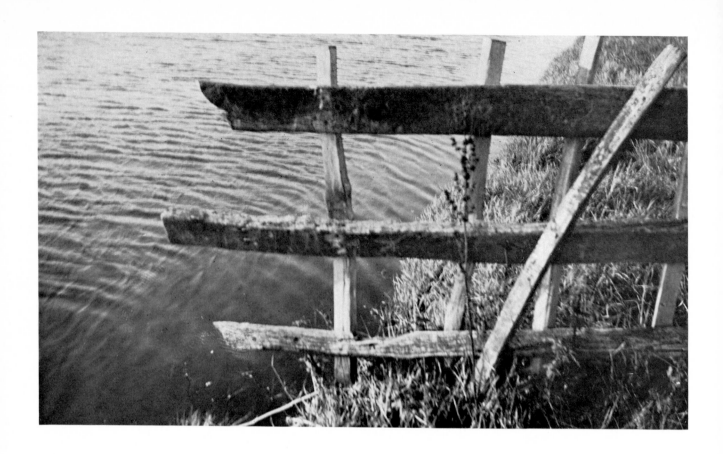

54 Fence by a River Bank

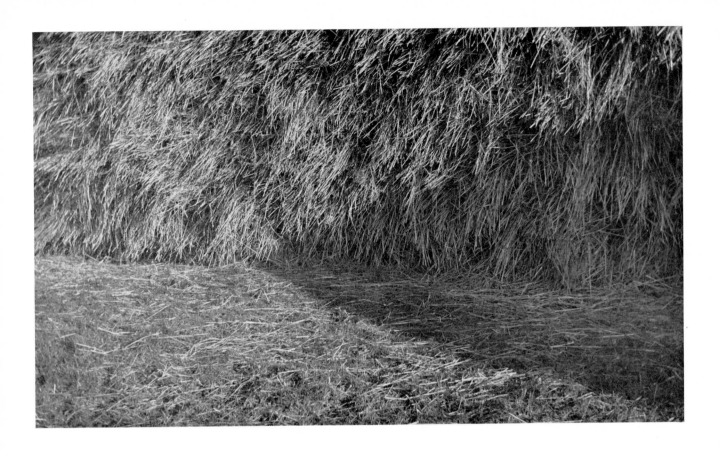

55 Haystack

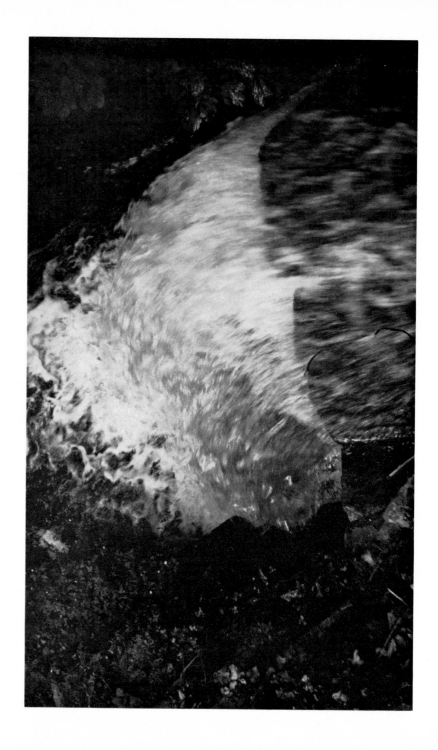

56 Waterfall

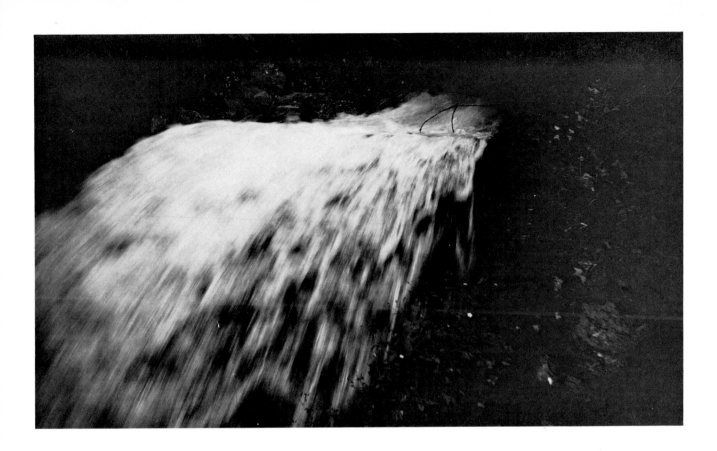

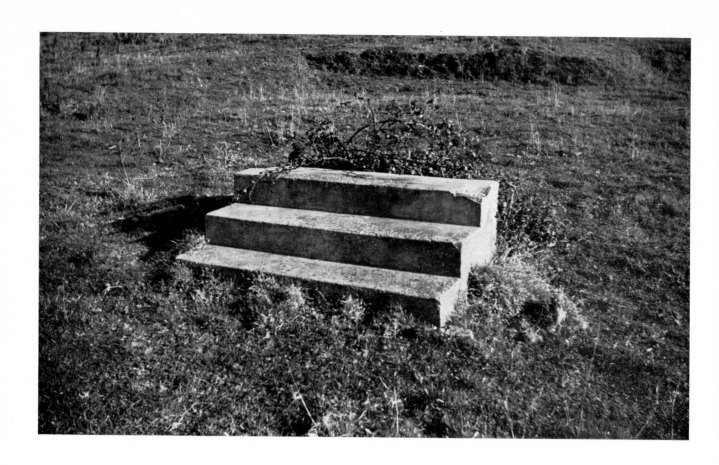

58 Steps in a Field near Swanage c.1935

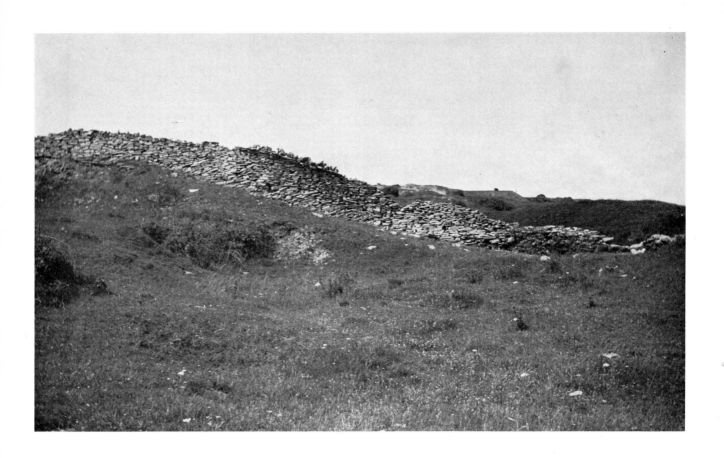

59 Stone Wall, Worth Matravers, Dorset c.1935*

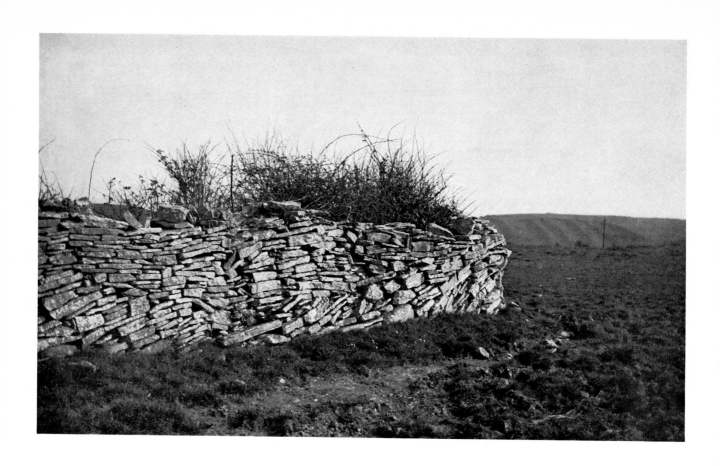

60 Stone Wall c.1935

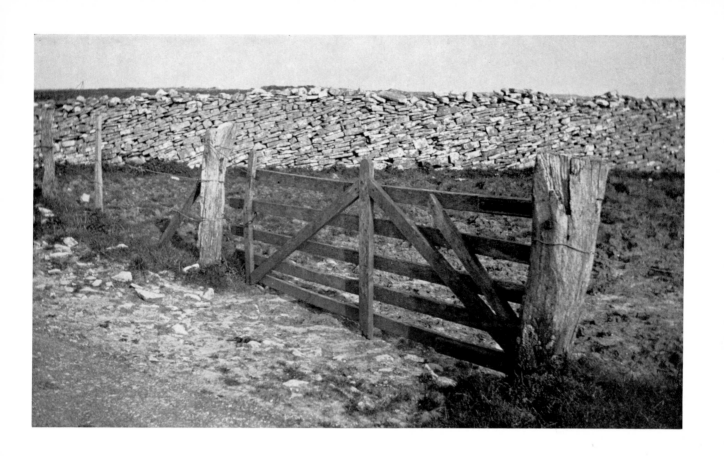

61 Stone Wall c.1935

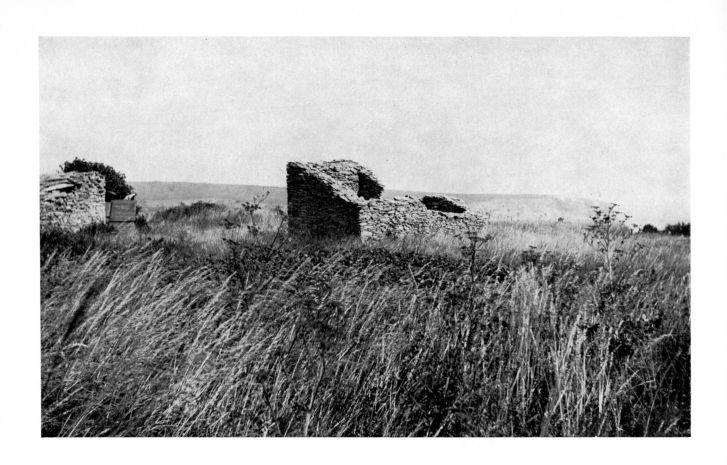

62 An Old Quarry Hut, Swanage c.1935*

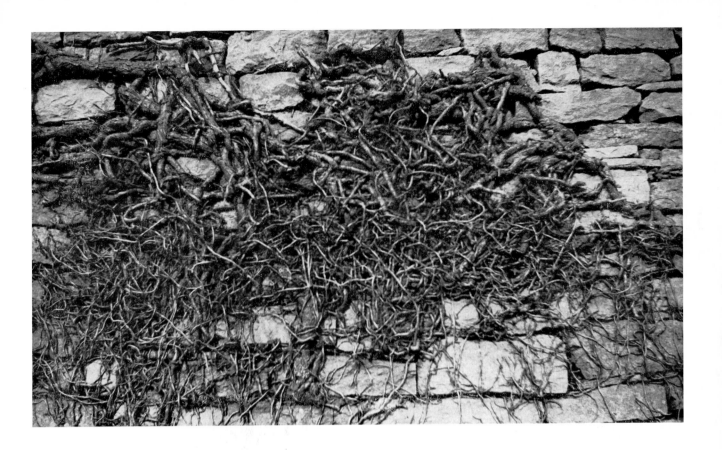

63 Ivy on a Stone Wall

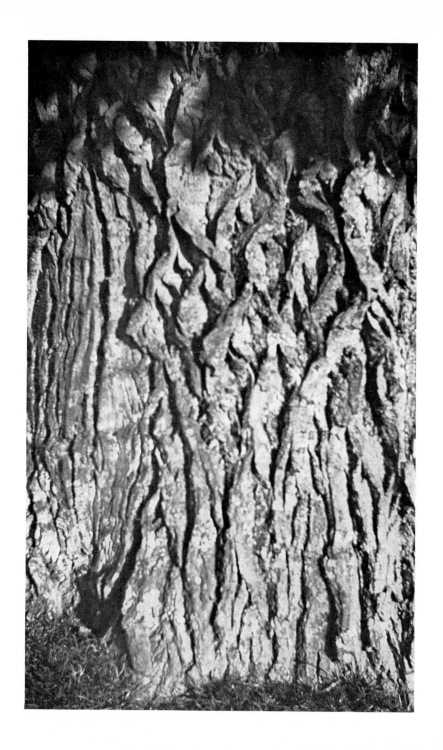

64 Detail of a Tree Trunk

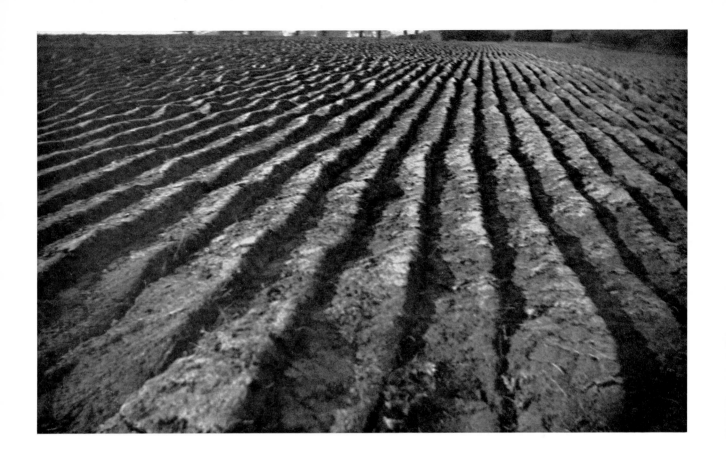

65 Ploughed Field c.1937*

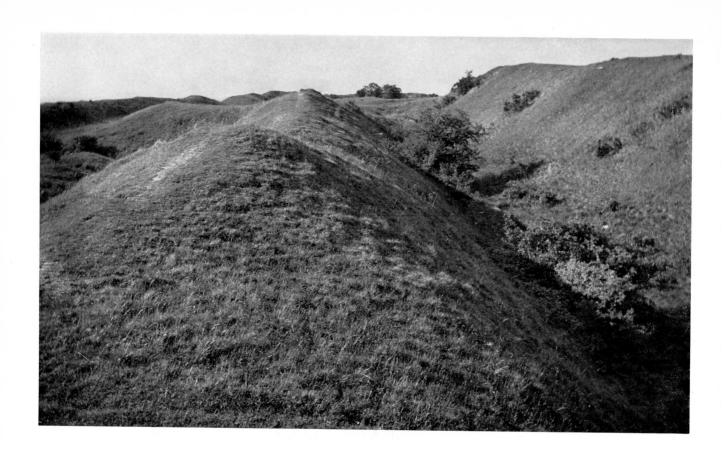

66 Maiden Castle, Dorset c.1935*

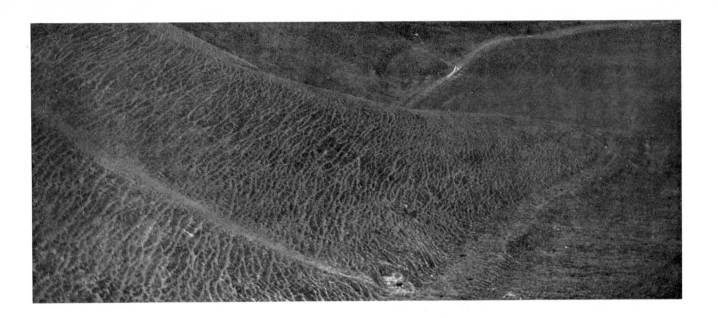

67 Maiden Castle, Dorset c.1935

68 'The Last Defenders of Maiden Castle', Dorset c.1935*

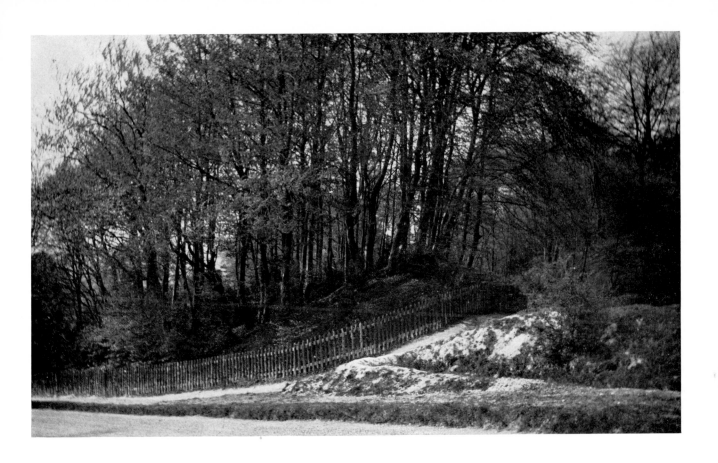

69 Whiteleaf Woods, Buckinghamshire

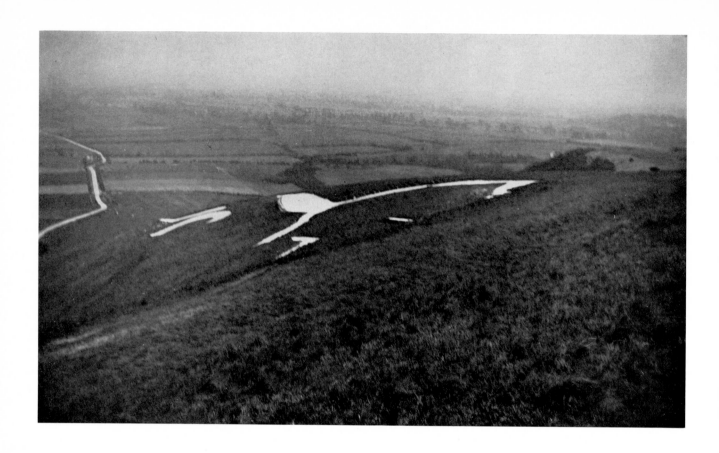

70 The White Horse, Uffington, Berkshire c.1937

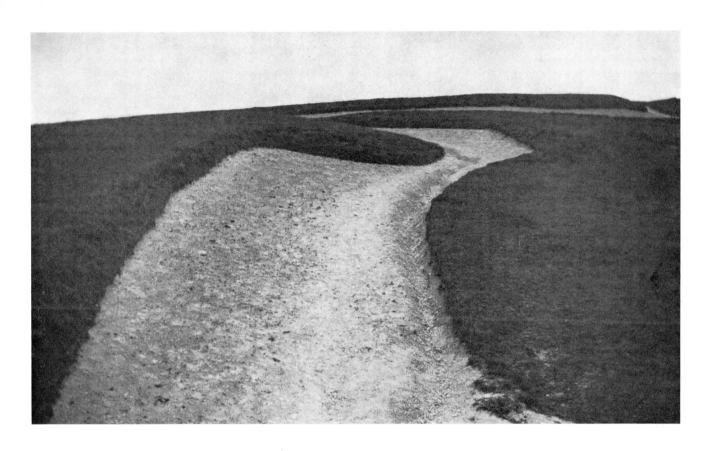

71 The White Horse, Uffington, Berkshire c.1937

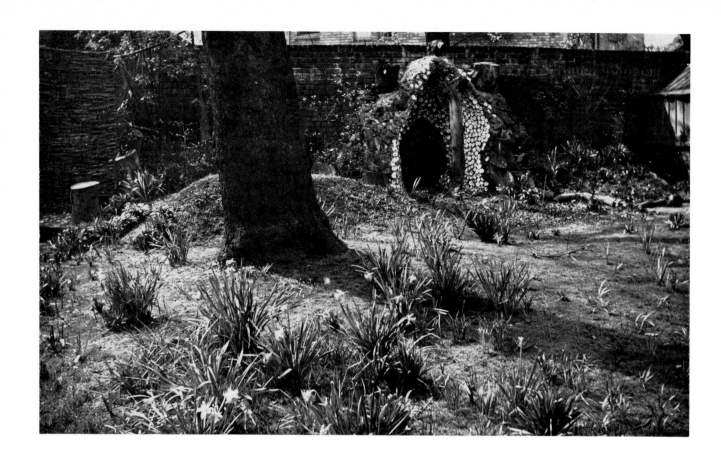

72 The Grotto at 3, Eldon Grove, Hampstead c.1936–9*

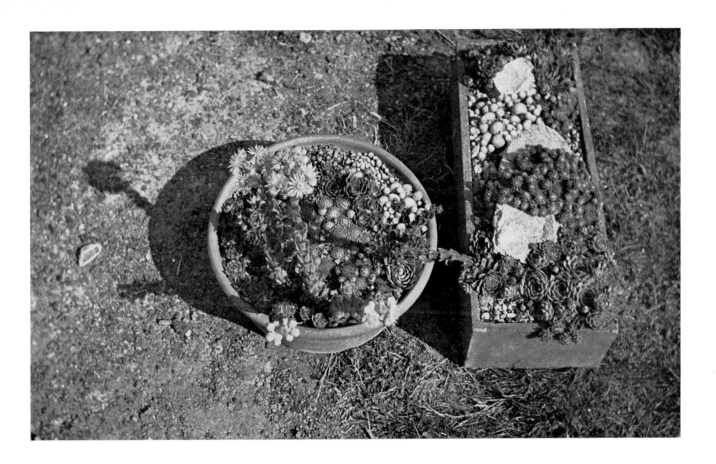

73 Pots of Houseleeks

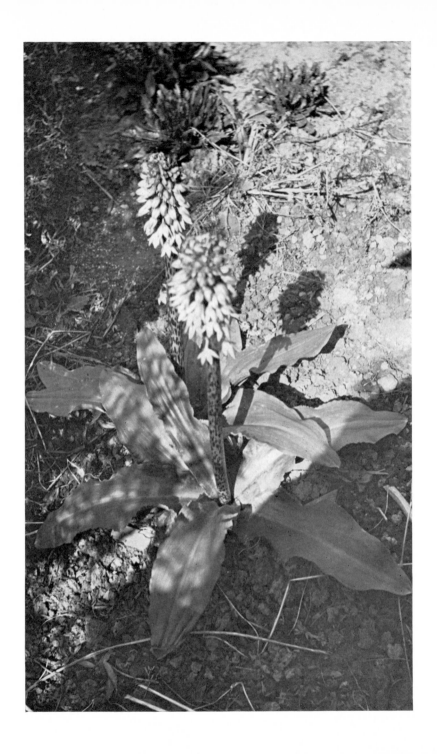

74 A Pineapple Flower with Nash's Shadow*

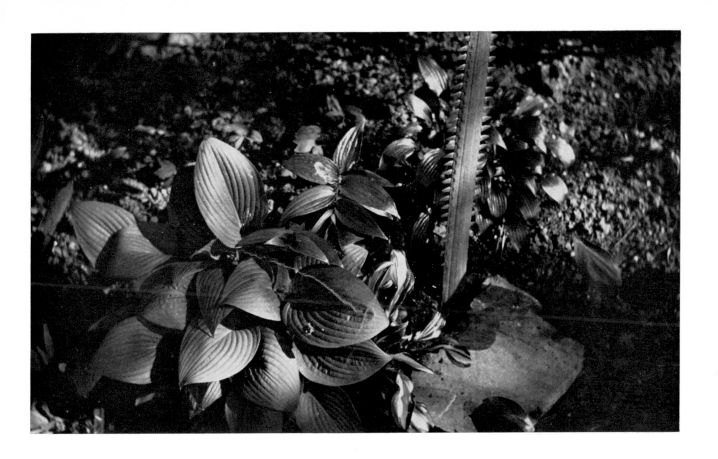

75 Border Plants and the Sword of a Swordfish

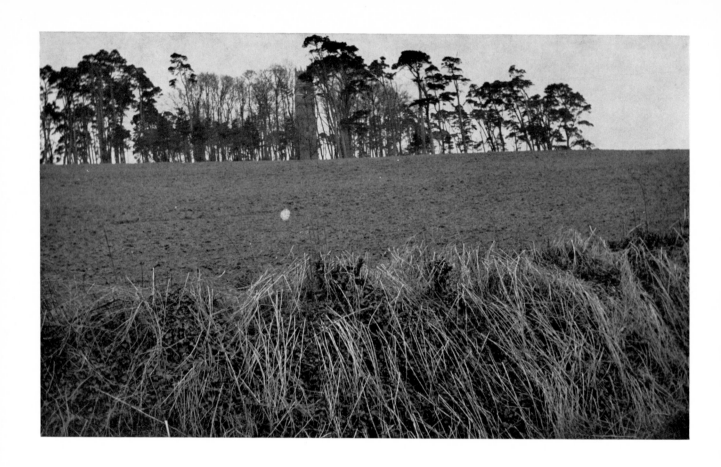

76 Lord Berner's Folly, Farringdon, Berkshire

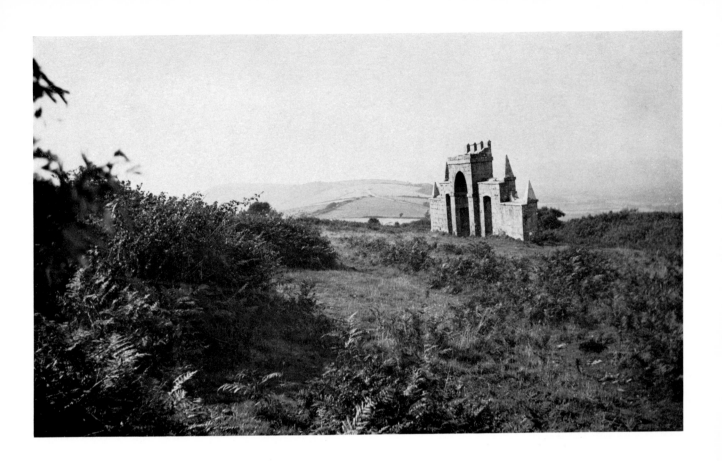

77 Creech Folly, Dorset 1937*

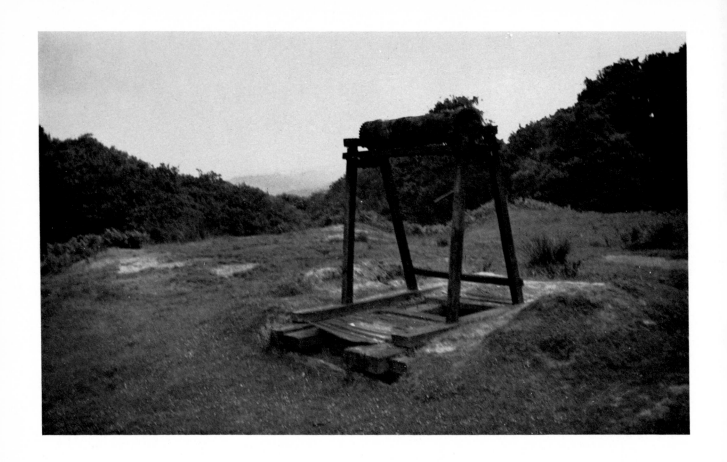

78 Derelict Mineshaft, Forest of Dean 1939*

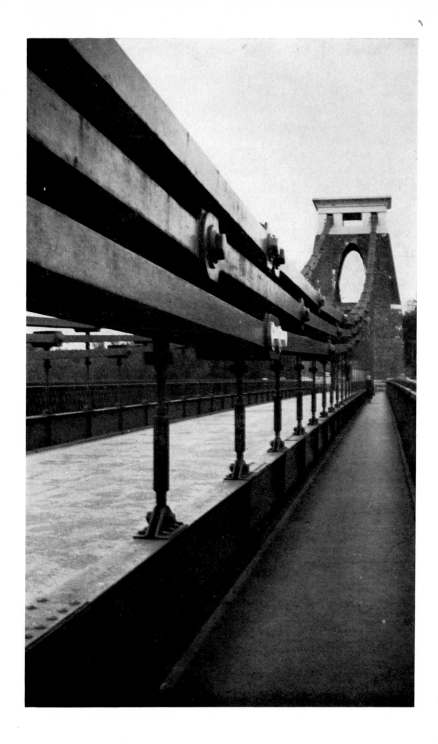

79 Clifton Suspension Bridge, Bristol 1939*

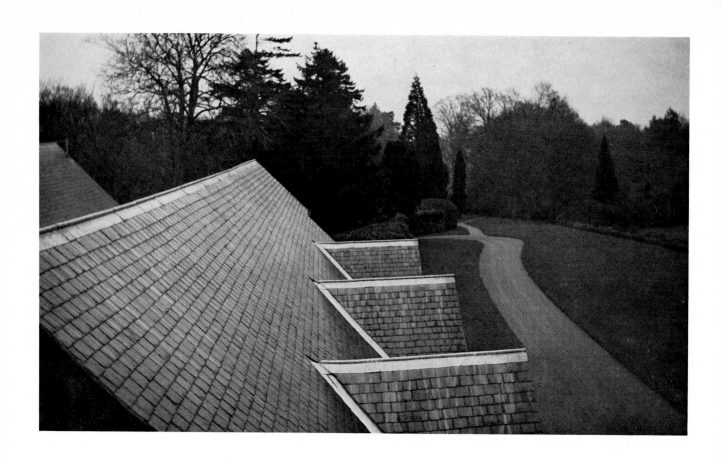

80 Gregynog, Montgomeryshire 1939*

81 Gregynog 1939

82 The Box Garden, Beckley Park, Oxfordshire c.1940–1*

83 'Haunted Garden' c.1940–1*

84 The Park Wall, Ascott Manor, Stadhampton, Oxfordshire*

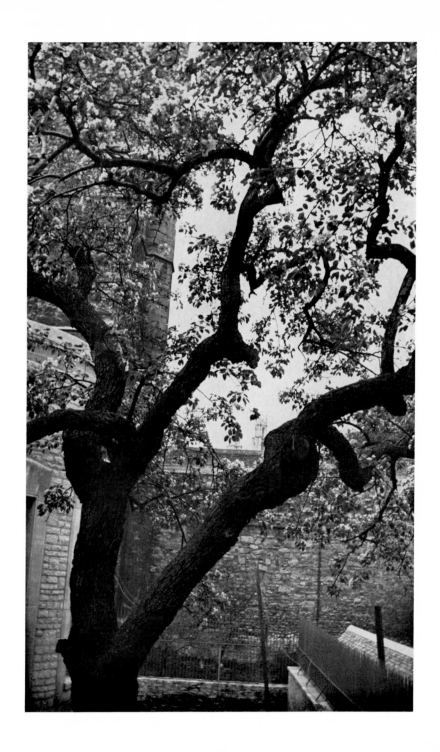

85 Flowering Tree, Oxford 1940s*

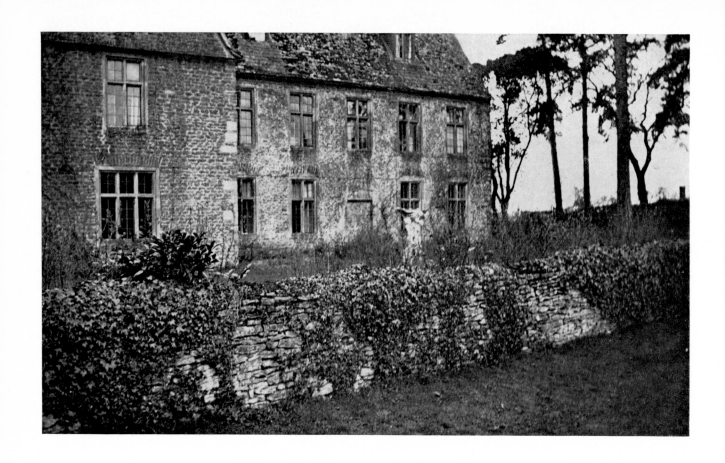

86 Country House

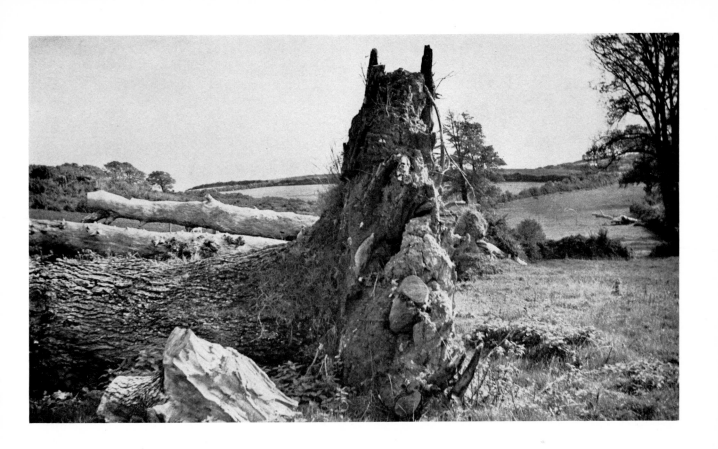

87 'Stalking Horse' 1939*

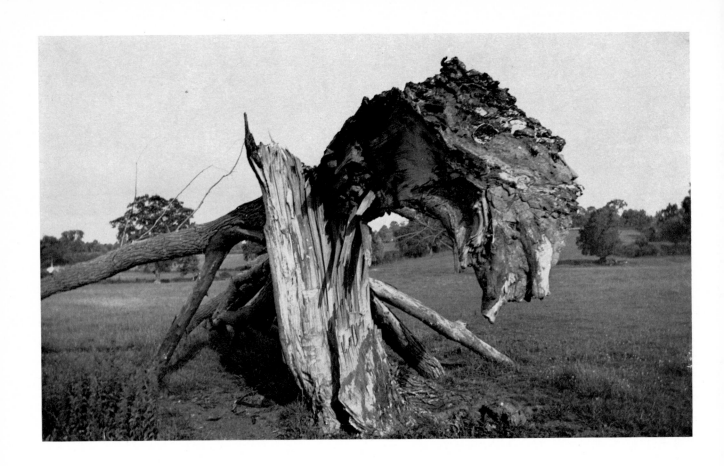

88 'Monster Field' 1939*

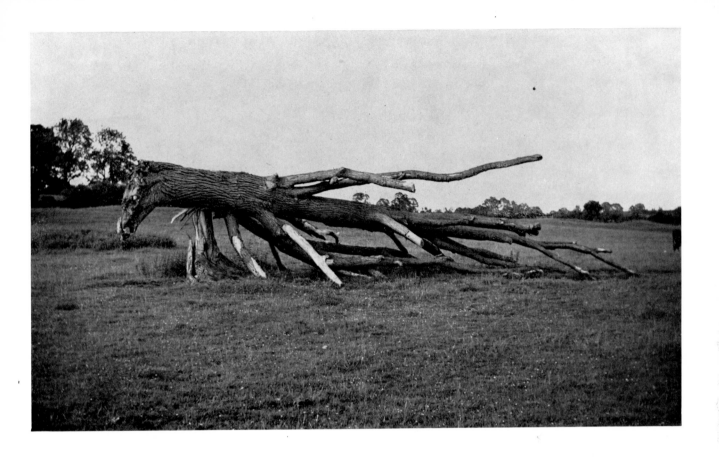

89 'Monster Field' 1939*

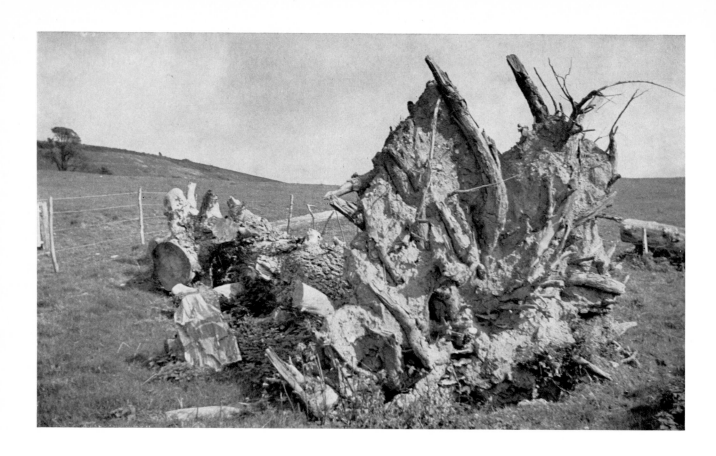

90 Uprooted Tree 1939

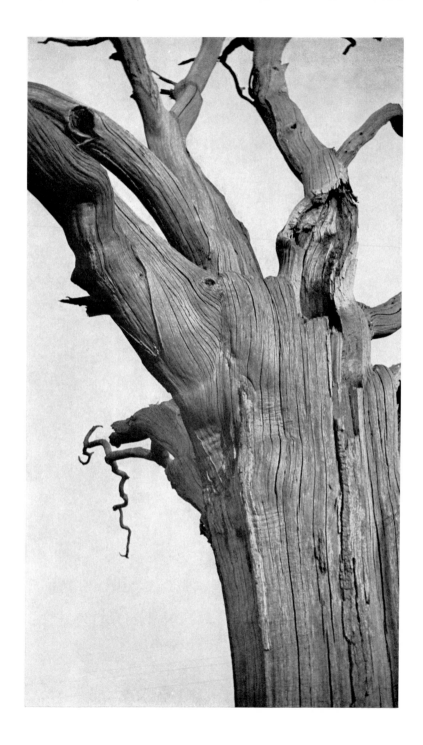

91 Dead Tree, Romney Marsh

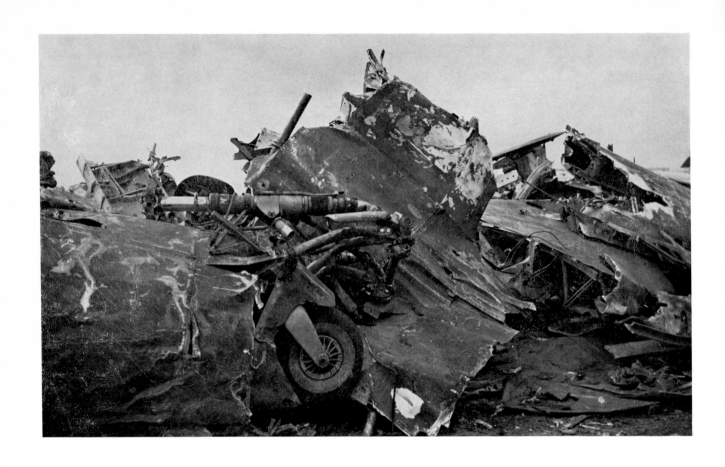

92 Wrecked Aircraft, Cowley Dump, Oxfordshire 1940*

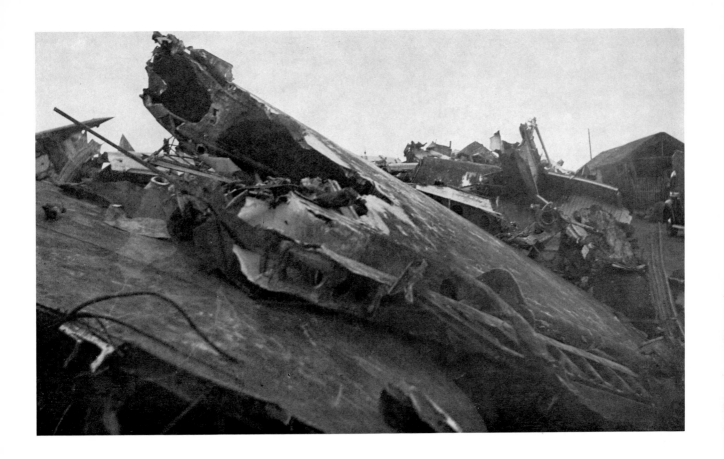

93 Wrecked Aircraft, Cowley Dump 1940*

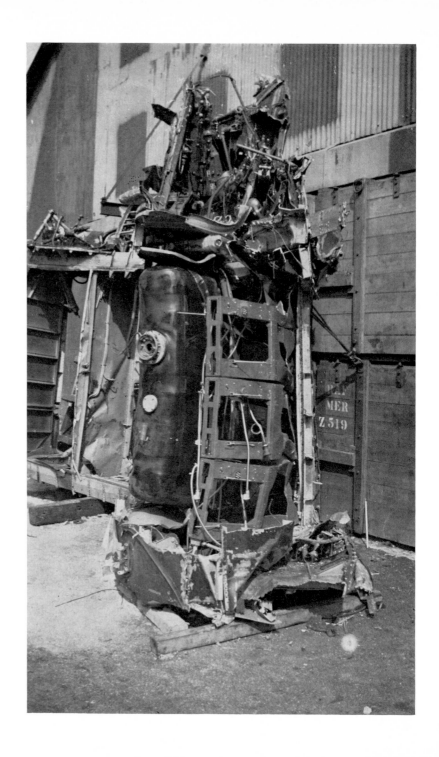

94 Wrecked Aircraft, Cowley Dump 1940

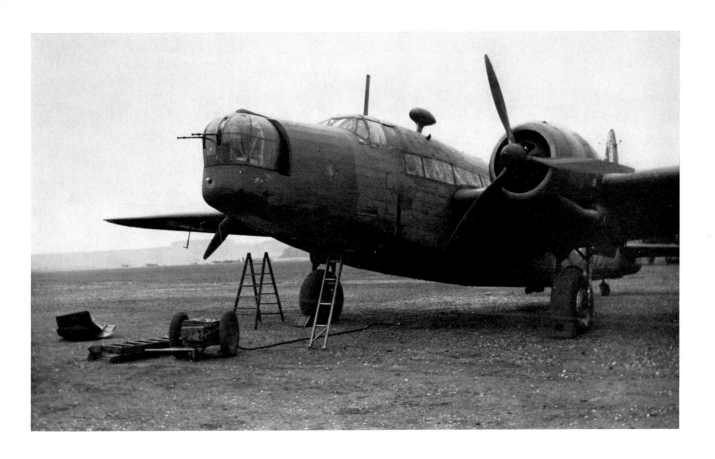

95 A Wellington Bomber 1940*

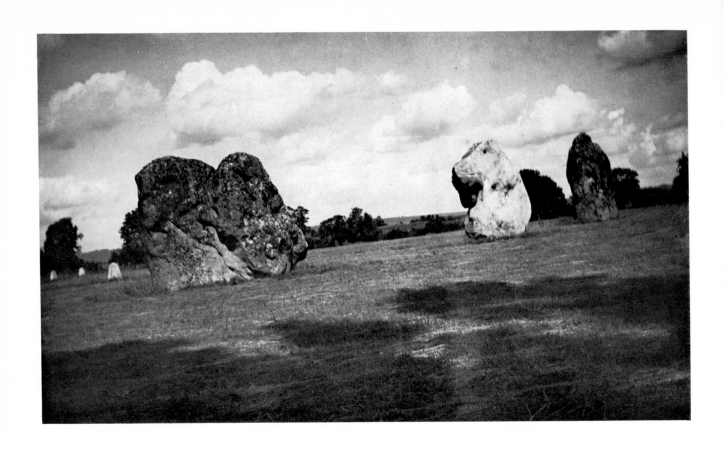

96 Stones at Avebury, Wiltshire 1942*

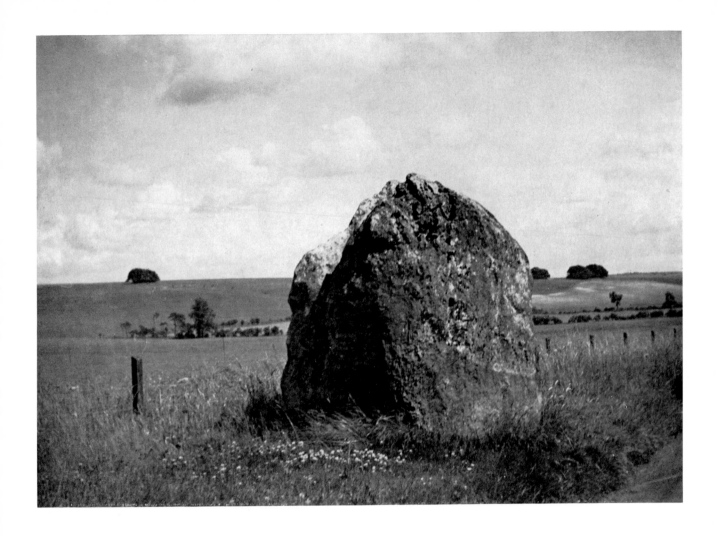

97 Avebury, Wiltshire 1942

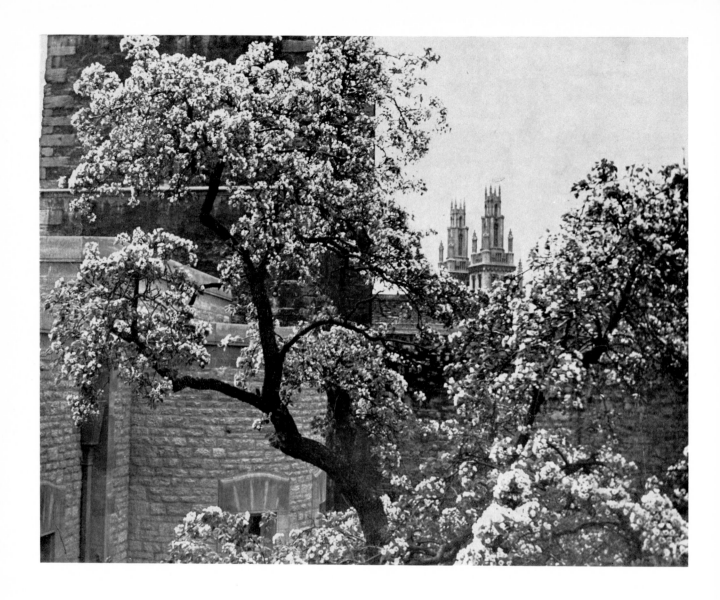

98 A Flowering Tree and the Towers of All Souls, Oxford 1940s

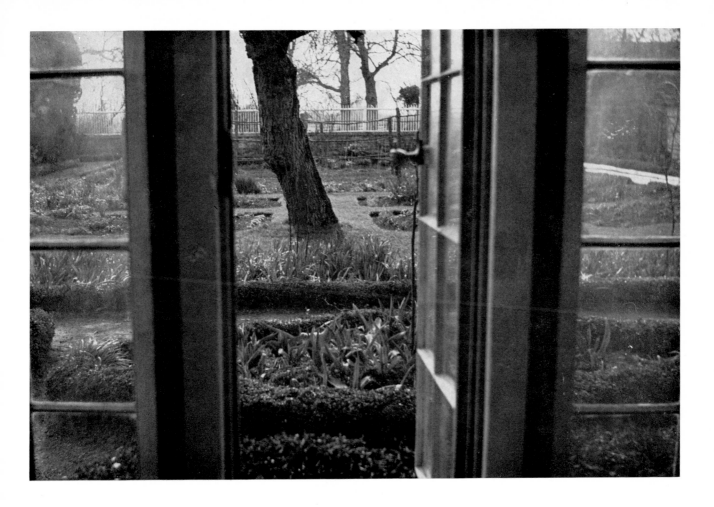

99 Kelmscott Manor 1941*

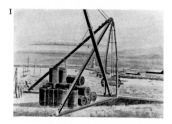

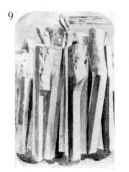

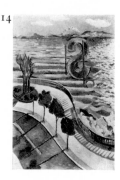

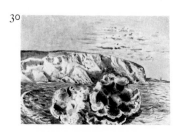

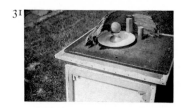

1 The photograph was used in the two watercolours 'Orford' signed and dated 1930. One (private collection) was first exhibited at Tooth's, December 1930. The second is in the collection of the Art Gallery of South Australia, Adelaide. (Repr.)

2–5 These photographs were taken during Nash's voyage to and from the United States in autumn 1931. He sailed on 12 September aboard the *Mauretania* and left New York on 9 October on the *Samaria*.

4 *Repr :* Raymond Mortimer, 'Nature Imitates Art', *Architectural Review,* Vol. LXXVII, 1935, pp.27–9; *Fertile Image,* 1951, pl.63.

9 Used for the watercolour 'Totems', 1932 (coll: Graves Art Gallery, Sheffield); it is similar to *Fertile Image,* 1951, pl.62.

10 On 13 February 1934 Margaret Nash sent to Edward Burra from Nice a picture postcard with a photograph, taken by Nash, of herself 'leading the monster artichokes in the Carnival procession'.

12 The shark is possibly a Tiger Shark, a species not normally found in the Mediterranean.

14 The Nashs stayed at the hotel during the winter, 1933–34. The reversed letter 'S' was made the subject of the oil painting 'View S' 1934 (coll: Cartwright Art Gallery, Bradford).

17 A related double-exposed photograph is reproduced in *Fertile Image,* 1951, pl.53.

20 *Exh : Paul Nash's Camera,* 1951 (32).
 Repr : Fertile Image, 1951, pl.48.

21 *Exh : Paul Nash's Camera,* 1951 (30).
 Repr : Fertile Image, 1951, pl.45.

23 The Nashs had a flat in the block from their marriage in 1914 till they bought a house in Hampstead in 1936.

27 *Repr :* Raymond Mortimer, 'Nature Imitates Art', *Architectural Review,* Vol. LXXVII, 1935, pp.27–9.

30 Used for the watercolour 'Voyage of the Fungus', 1935 (coll: Edward James Foundation).

31 Nash made pl.31 by trimming a larger photograph.

33 *Exh : International Surrealist Exhibition,* 1936 (number unknown); Gordon Fraser Gallery, Cambridge, 1939 (23); CEMA touring exhibition, 1943 (47); *Paul Nash's Camera,* 1951 (34).
 Repr : Fertile Image, 1951, pl.52.

35 Incorporated into the photo-montage 'Empty Room', 1937, which was reproduced in 'Unseen Landscapes', *Country Life,* Vol. LXXIII, 1938, pp.526–7; *Fertile Image,* 1951, pl.51.

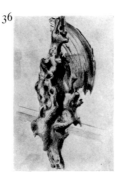

36 *Exh : Paul Nash's Camera,* 1951 (59).

 Repr : P. Morton Shand, 'Object and Landscape', *Country Life,* Vol.LXXXV, 1939, pp.592–3; *Fertile Image,* 1951, pl.59.
This was a found object discovered in the Rother Valley, Sussex. Nash wrote to his friend Clare Neilson (6 August 1934): 'Yesterday I found a superb piece of wood sculpture (salvaged from a stream) like a very fine Henry Moore. It is now dominating the sitting-room waiting for a bright sun to be photographed.' A pencil drawing of it is titled 'Wood Fetish' (coll: Sir Michael Culme-Seymour, Bt.).

37 *Repr :* 'The Life of the Inanimate Object', *Country Life,* Vol. LXXXI, 1937, pp.496–7.

 It is similar to *Fertile Image,* 1951, pl.60.

38 A tree root named after the legendary Tibetan runner because of his long legs.

39 *Exh : Paul Nash's Camera,* 1951 (18).

 Repr : Fertile Image, 1951, pl.27.

40 Another very similar photograph of this motif was mounted in a folder which Paul Nash gave to Lance Sieveking in January 1935; it was entitled 'Snape'.

41 Nash wrote in the *Dorset Shell Guide,* p.32: 'Alfred the Great Monument. A column surmounted by four cannon balls . . . in commemoration of a great naval battle fought with the Danes in Swanage Bay by Alfred the Great, 877.'

42 *Repr :* 'Swanage or Seaside Surrealism', *Architectural Review,* Vol. LXXIX, 1936, pp.151–4.

45 *Exh : Paul Nash's Camera,* 1951 (4).

 Repr : Fertile Image, 1951, pl.6.

46 Nash wrote to Anthony Bertram in an undated letter (probably September 1935): 'A swan appeared in the bay last Monday and got badly hustled by some rude waves'.

47 Very similar to *Fertile Image,* 1951, pl.3.

49 *Exh : Paul Nash's Camera,* 1951 (2).

 Repr : Dorset Shell Guide, 1936, pl.4.

 Fertile Image, 1951, pl.4.

51 *Repr : Fertile Image,* 1951, pl.10. Used for the photo-montage, reproduced on back cover of *Dorset Shell Guide.*

59 Used in the watercolour 'Stone Sea', 1937 (coll: Mrs Malcolm MacBride).

62 Similar to a plate in *Dorset Shell Guide,* 1936, p.12.

65 Used for the watercolour 'Earth Sky', 1937 (private coll.).

66 Three watercolours relate to the Maiden Castle photographs: 'Hill Architecture', c.1935–7 (private coll.); 'Maiden Castle', 1937

(coll: Robert Hull Fleming Museum, Univ. of Vermont); 'Maiden Castle' (coll: Sir Michael Culme-Seymour) made after a later visit to Dorset in 1943.

68 *Exh : Paul Nash's Camera,* 1951 (31).

 Repr : Fertile Image, 1951, pl.46.

A similar photograph was reproduced in 'Unseen Landscapes', *Country Life,* Vol. LXXXIII, 1938, pp.526–7.

7 Nash built the grotto in the garden of the house where he lived from 1936 to 1939 with the help of an Italian craftsman who used a traditional technique of cementing oyster shells onto rough sandstone. The grotto became the subject of several pictures including an oil painting 'Grotto in the Snow' (Tate Gallery) and watercolours belonging to Mrs James Fell, Mrs Davidson Swift and the Edward James Foundation.

74 *Repr : Fertile Image,* 1951, pl.55.

76 Lord Berner's folly, completed in 1935. It stands on a hill about a mile outside Farringdon, on the Oxford Road.

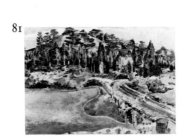

77 Nash wrote to his wife (letter dated 31(*sic*) September 1937) from Furzebrook House, Wareham where he was staying with friends: 'I have done three watercolours, Kimmeridge Folly, Creech Folly and the Blue Pool and taken a good whack of photographs.' This photograph may have been among them. The watercolour of Creech Folly belonged to the late H.K. Lund.

78 Nash regularly visited his friends Clare and Charles Neilson who lived near the Forest of Dean from 1938. The winding gear was used in the watercolour 'Forest of Dean', 1939 (coll: Mrs James Fell).

79 The Nashs visited Bristol in March 1939; their hotel room overlooked the Avon Gorge and the Bridge. The photograph was used to illustrate an article on the history and mythology of the bridge, 'The Giant's Stride', *Architectural Review,* Vol. LXXXVI, 1939, pp.117–20. Nash also did many watercolours of the Gorge, including 'To the Memory of Brunel' (coll: British Council) and 'Woods on the Avon Shore' (coll: Graves Art Gallery, Sheffield).

80 Nash visited Gregynog near Newtown, Montgomeryshire, in April 1939 to meet the Misses Davies who ran the Gregynog Press there, and to discuss a project for Nash to design the binding of Bernard Shaw's *Shaw Gives Himself Away.* Nash's design (repr. *Architectural Review,* Sept. 1947) was rejected.

81 Used for the watercolour 'Gregynog', 1939 (Private coll.).

82 *Exh : Paul Nash's Camera,* 1951 (29).

 Repr : Fertile Image, 1951, pl.42 (wrongly titled 'The Haunted

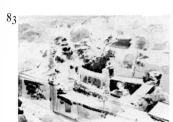

83

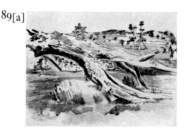

89[a]

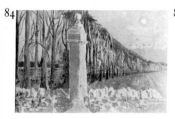

84

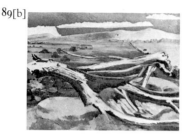

89[b]

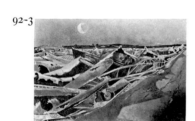

92-3

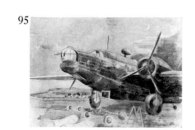

95

Garden'). Used for the watercolour 'The Box Garden', 1943 (coll: estate of Royan Middleton).

83 Used for the watercolour 'The Haunted Garden', 1941 (coll: Ashmolean Museum, Oxford).

84 The park and surrounding wall were used in the picture 'Pillar and Moon', 1940 (coll: Tate Gallery).

85 The tree is the same as that in pl.98.

87 *Exh: Paul Nash's Camera*, 1951 (24).

Repr: Fertile Image, 1951, pl.34.

Used for the watercolour 'Stalking Horse', 1941 (destroyed).

88 *Exh: Paul Nash's Camera*, 1959 (32).

Repr: Paul Nash, Monster Field, 1946, *Fertile Image*, 1951, pl.32. Nash's essay *Monster Field* was an imaginative history and character study of the dead trees which he discovered in a field in the Severn Valley in Gloucestershire while staying with the Neilsons at Madams just before the war.

89 Used for the watercolour 'Monster Field Study 1', 1939 (coll: Lord Croft) [a] and was employed together with another photograph of a tree for the oil painting 'Monster Field' 1939 (coll: Durban Art Gallery)[b].

92-3 Incorporated in the painting 'Totes Meer', 1940–41 (coll: Tate Gallery).

95 Nash visited airfields while employed as an Official War Artist by the Air Ministry between March and December 1940. The bulk of his war work was done in that year, though he continued to work as a War Artist for the Ministry of Information until 1944. The photograph was used for the watercolour, 'Making ready. Wellington being bombed up' 1940 (coll: Town Hall, Warrambool, Victoria, Australia).

96 Nash first encountered Avebury in July 1933, and the stones provided material for several of his paintings in the following years. He was interested in the history and the meaning of the stones, and owned a copy of William Stukeley's classic book *Avebury. A Temple of the British Druids with some others*, 1743. He was friendly with Alexander Keiller, the archaeologist who reinstated the stones in the later thirties but felt the loss of the wild undergrowth which had surrounded them. Of his last visit there in 1942 he wrote to his dealers, Tooths: 'They were altogether changed in appearance collectively. The work of re-instating and ordering the Circles had been completed. Sometimes the effect was immensely impressive. I made a few rapid drawings and took a spool of photographs. Again the spell of these deeply moving monuments began to work upon me.'

99 Nash's visit to Kelmscott and his ambition to write about Rossetti's association with the house coincided with his revived interest in Rossetti in the last years of his life. No article was published but the results of his research are now in the Tate Gallery Archives. The course of his enquiries can be followed in his correspondence with Gordon Bottomley whom he plied with questions about Rossetti during 1941 (ed. C.C. Abbott and A. Bertram, *Poet and Painter, being the correspondence between Gordon Bottomley and Paul Nash, 1910–46*, 1955).